What is to be Done with our World?

Forty Stases and Theses

40 Problems and their Solutions for a World Order

by Alfred de Grazia

Illustrated by Licia Filingeri

metron

ISBN: 978-1-60377-083-5
Library of Congress Number: 2001012345
Copyright 2006-2013 by Alfred de Grazia
All Rights Reserved
METRON PUBLICATIONS
P.O. Box 1213 PRINCETON, NJ 08540-1213

Forty Stases and Theses

What is to be Done With Our World?
Forty Basic Problems and Their Solutions: Forty Stases and Theses

By Alfred de Grazia

This, a prose poem about the crisis of the present world age,
was originally written by Professor Alfred de Grazia in 1971,
and delivered to a faculty seminar at New York University.
In 1994 it was presented as the basis for a collaboration
with the artist and psychotherapist, Licia Filingeri, of Genoa,
noted for her abstract and surreal papier mâché sculptures,
and the work culminated in a set of forty paintings,
acrylic on paper posters, by her in consultation
with Alfred de Grazia, who also autographed the inscriptions.
The work was completed in Genoa, Italy, in October 1995.
They called it "Quantavolution Art," meaning that the art
symbolizes and proposes large-scale, extensive,
radical change over short time periods.

Definitions:

A stasis posits a trouble or problem.
A thesis offers a solution in the area of the problem.
Each stasis requires proof, as does each thesis.
These are provided mainly in the larger work,
Kalos: What is to be Done with Our World? (Bombay, India, 1971).
The stases, read in succession, from number 1 to number 40,
afford a general diagnosis of conditions.
Each thesis stands opposite a related stasis and proposes a general
alternative to it. The theses thereupon set forth a full and integrated
system for the betterment of man's condition -- the world of Kalos.

A world order exists, in fact, a kind of world government exists.
But it is bad. The purpose of Kalotics here is to declare
in what forty general respects it is bad and how in each regard
a solution is possible that will altogether add up
to a beneficial and benevolent world order and government.

The 40 Stases and Theses Project

Alfred de Grazia has written
about the project
and Licia Filingeri
in a letter, as follows:

"She was also a psychotherapist (with a special practice helping troubled priests).
I was not only armed by the best School of Political Science of the century,
but have been for sixty-one years an agitator in various guises on behalf
of world unity. A year ago, reflecting upon how manifest in her art
-- see her Bosnian sculpture, for instance --
was Licia's concern for humanity, how fervent, I broached to her these paintings,
and soon we were at work transmogrifying into surreal art my abstract propositions
designed to quantavolute the world.
"Reminds me of Picasso and 'Guernica'," someone said.
In a way, yes, but Picasso showed the hell of war alone,
terror without recourse, and without fumetti, the word balloons.
The Kalotics series of ours, like Dante's Divine Comedy,
pictures Paradiso as well as Inferno,
but without naming personages.

"No one pretends that the art is easy to grasp at first sight.
Both the symbolism and the text are difficult,
even slightly cabalistic, but this "secretiveness" comes from the intensity
of handling so much visual and intellectual material
in limited frames, and disappears if one has recourse to the original work "Kalos."

"A conjecture occurred in conversation with the Public Affairs Director
of the Woodrow Wilson School of Politics at Princeton University last Spring.
We were discussing an exposition of the Kalotics
at its new Marver and Sheva Bernstein Gallery next winter.
The pictures are difficult to comprehend as a story, but are intriguing;
the propositions are hard to grasp, too, being highly general and abstract,
possibly shocking, and employing various exotic terms:
so the viewer will look at the picture and turn in perplexity to the words
and thereupon turn back to the picture, and will also go from thesis to stasis and back,
and from one number to another and back.
In all, her mind will be churning, and if she is in company,
conversation and argument will ensue.
The result will be a multi-media experience more intense and creative
than ordinarily occurs in contemplating painting and literature.
Or so goes the guiding theory."

1

STASIS :

The troubles of the world --
wars, famine, crowding, hate -
are interconnected and their effects are worldwide;
their proposed solutions are
piecemeal, isolated, special.

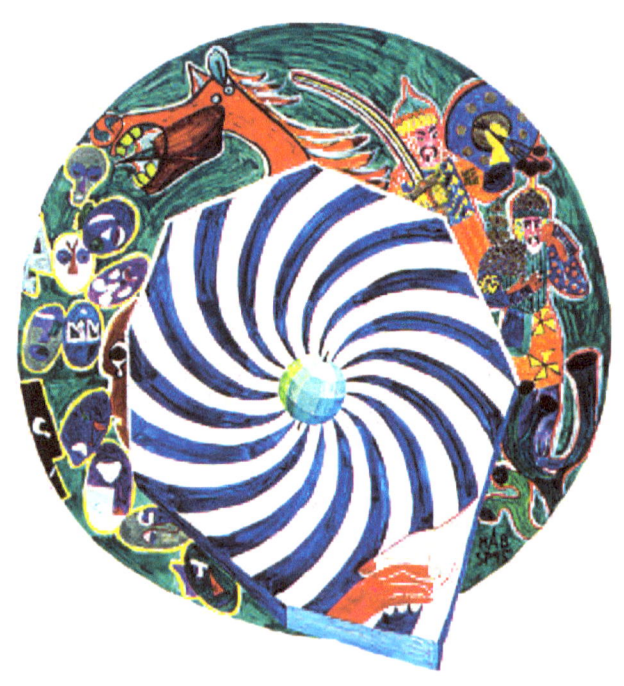

THESIS :

The solution of the World's Major troubles
must be universal, general and integrated,
a movement throughout the Full Circle
of Social Space.

S-1 The *troubles* of the World -- war, famine, crowding, hate -- are interconnected, and their effects are world-wide; their proposed solutions are piecemeal, isolated, partial.

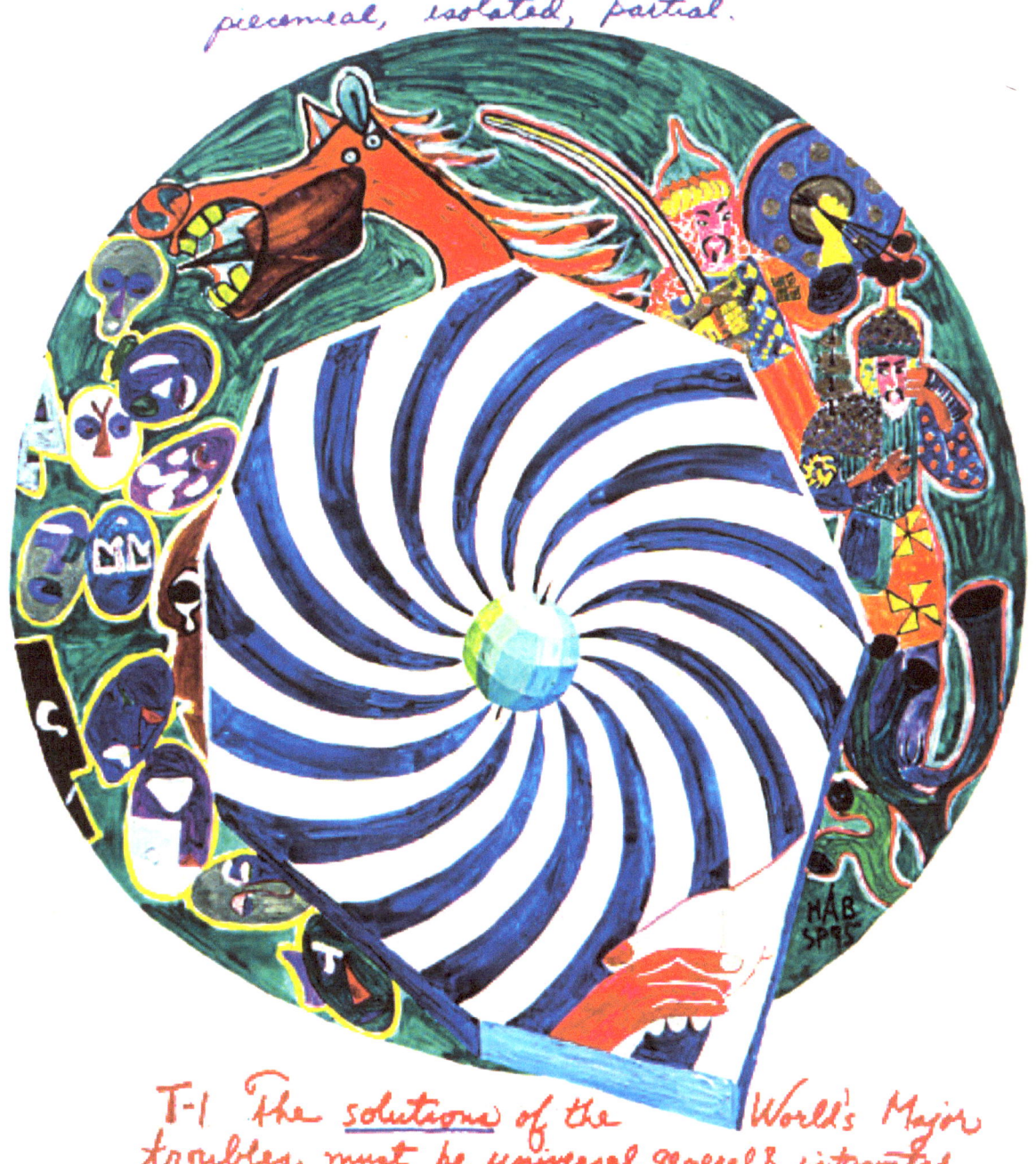

T-1 The *solutions* of the World's Major troubles must be universal, general & integrated, a movement throughout the Full Circle of Social Space.

2

STASIS:

The problems of the World are worsening
individually and collectively,
and moving toward one or another
Catastrophic Resolution.

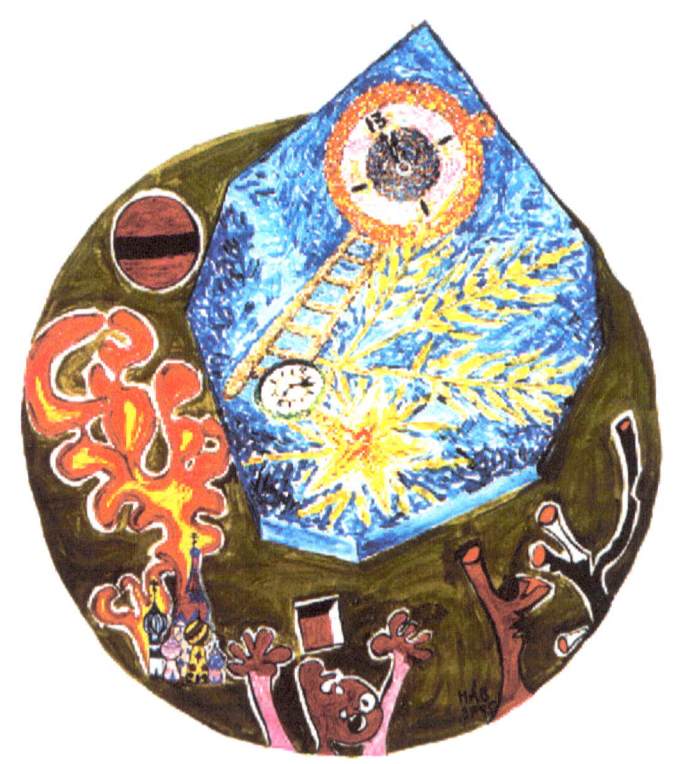

THESIS:

Invention and Applications of methods of large-scale,
world-wide, intensive, and rapid change
-- Quantavolutions --
are the first priority of humans
in the new generation.

S-2 The problems of the World are worsening, individually & collectively, and moving toward one or another Catastrophic Resolution.

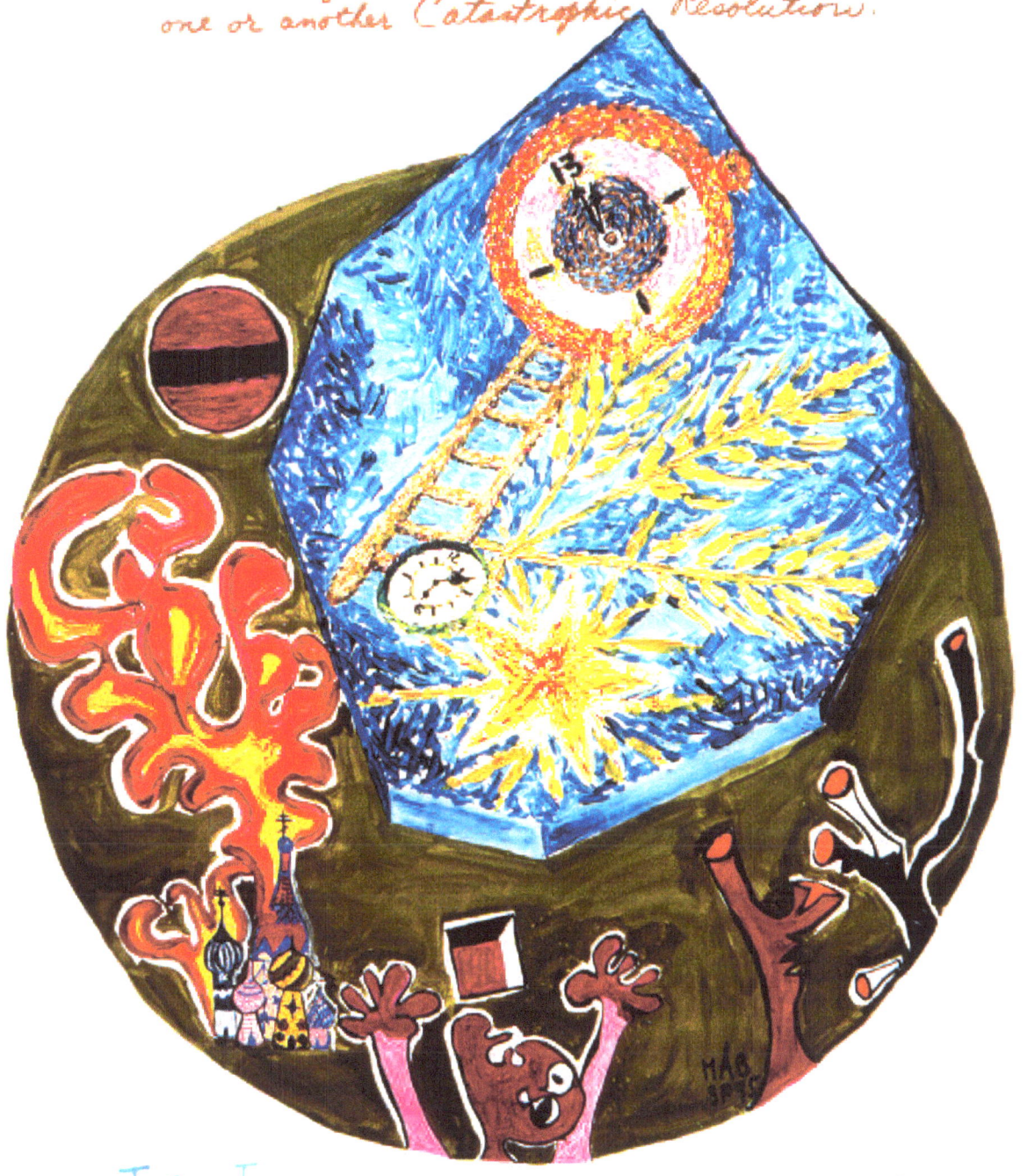

T-2 Inventions and Applications of methods of large-scale, world-wide, intensive, & rapid change -- QUANTAVOLUTIONS -- are the first priority of humankind in the new generation.

3

STASIS :

Most people are trapped by education
and circumstances to give the world
only what they receive, or make it worse;
few leave the World richer for their work.

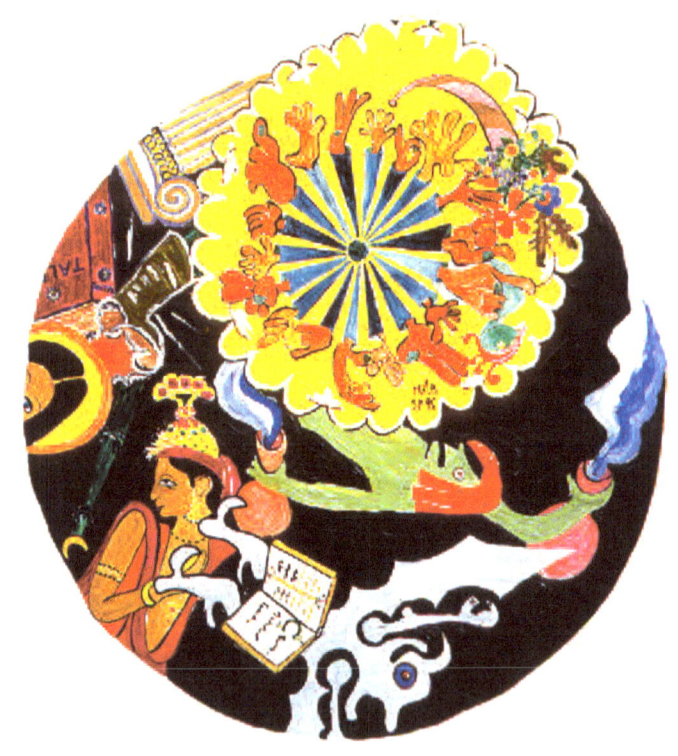

THESIS :

A million persons around the world
must be mobilized in a common effort
to develop and institute
a beneficial world revolution.

S-3 Most people are trapped by education & circumstances to give the World only what they receive, or make it worse; few leave the World richer for their Work

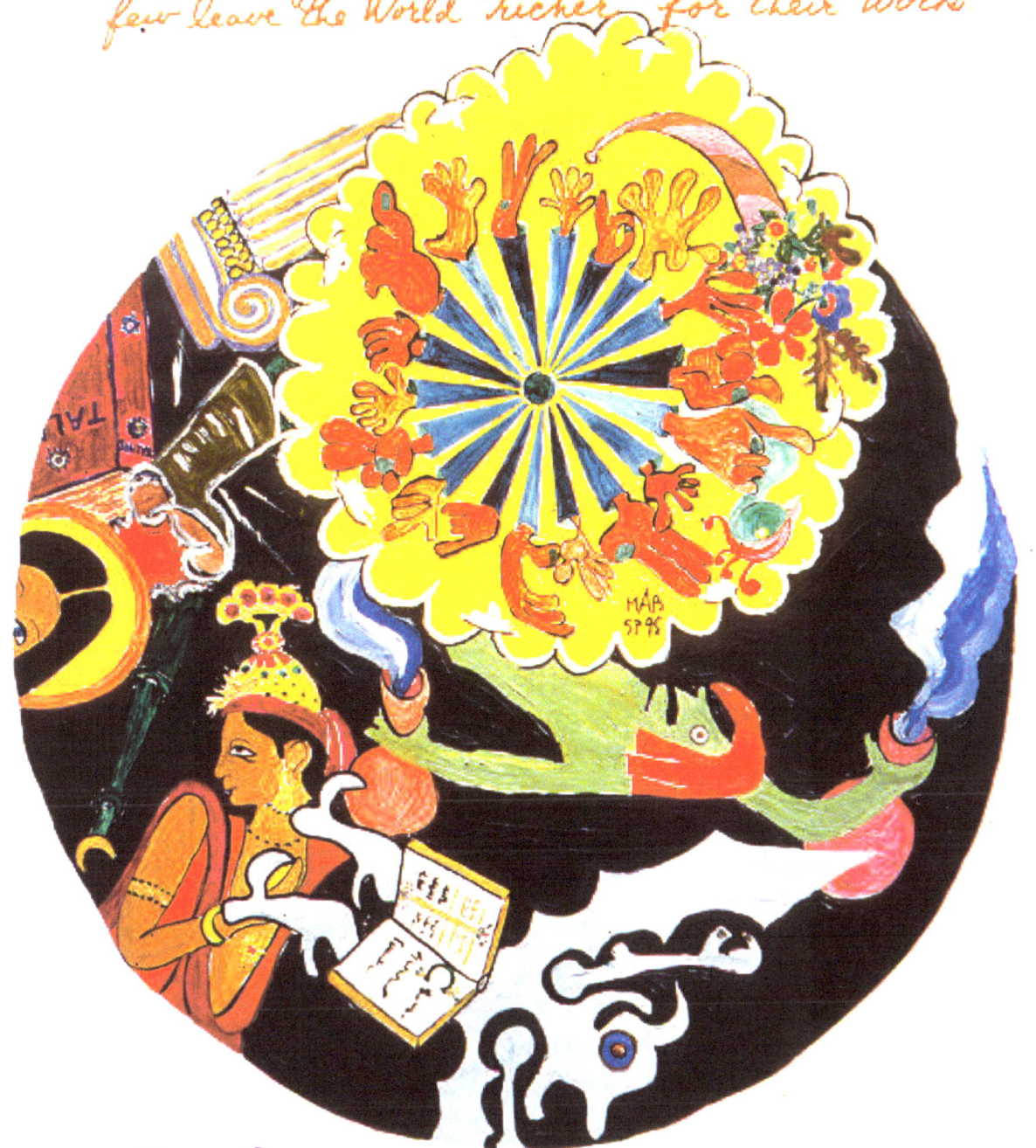

T-3 A million persons around the World must be mobilized in a common effort to develop & institute a beneficial world revolution.

4

STASIS:

Authority in all its present forms
-- traditions, laws, sheer domination --
is dying; authority is above all
what people believe in,
and the world disbelieves.

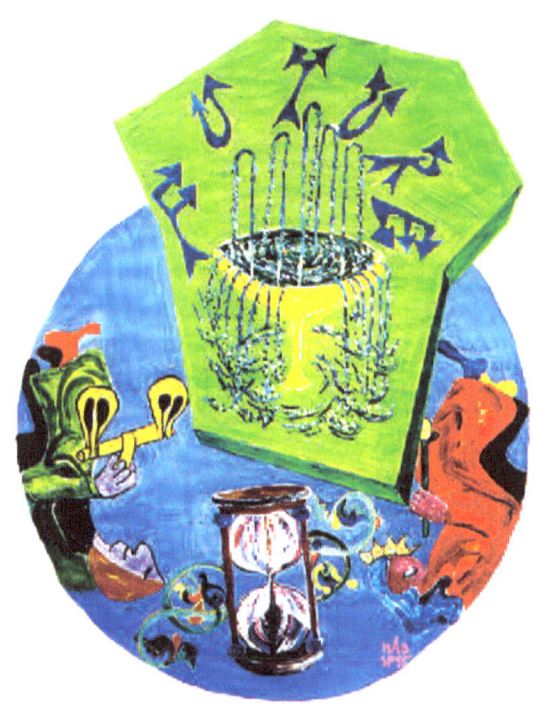

THESIS:

The fountainhead of authority
for a beneficial revolution
is the agreed-upon future,
with scientifically achievable ideals,
and as complete as possible.

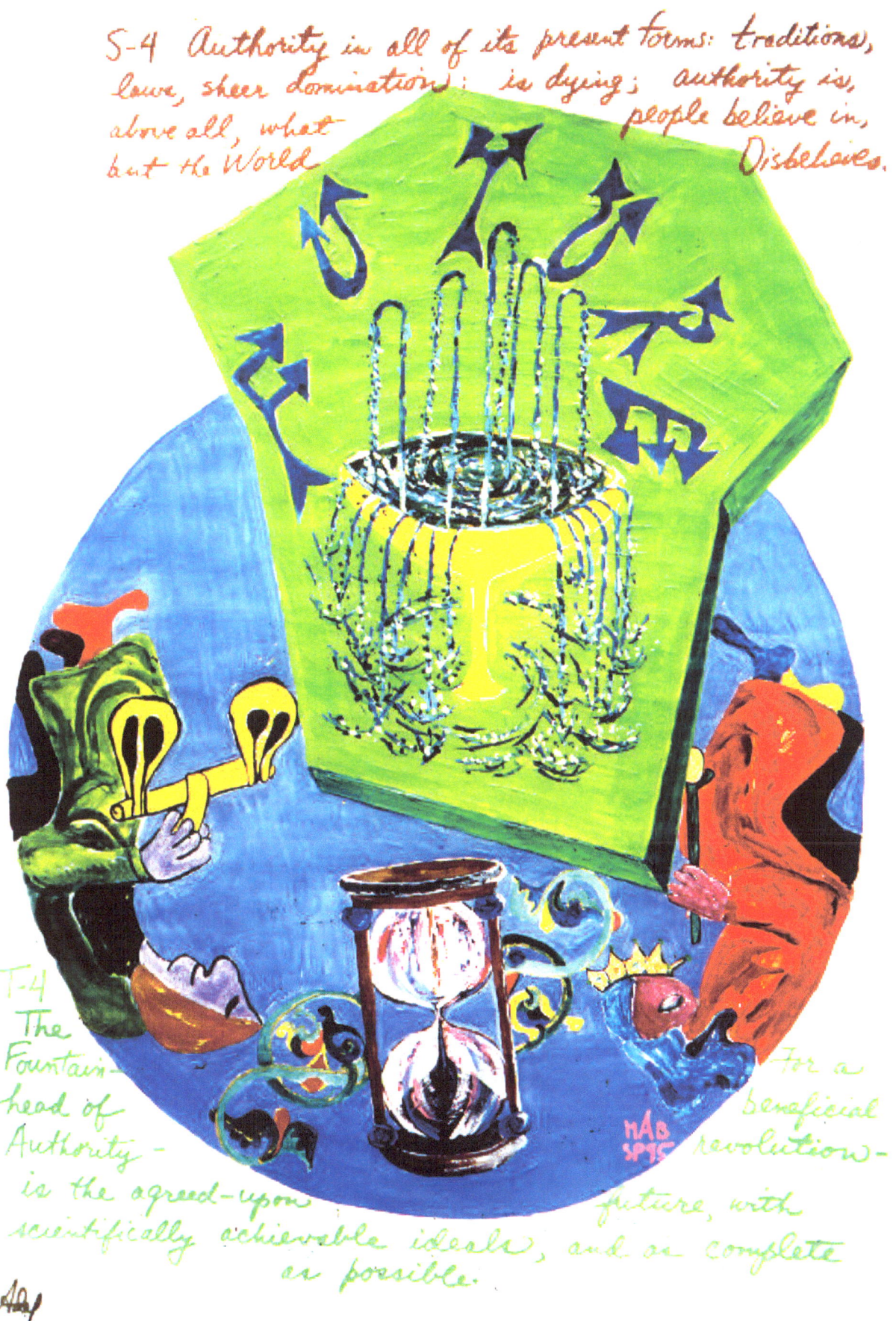

S-4 Authority in all of its present forms: traditions, laws, sheer domination; is dying; authority is, above all, what people believe in, but the World Disbelieves.

T-4 The Fountainhead of Authority — is the agreed-upon scientifically achievable ideals, and as complete as possible. For a beneficial revolution — future, with

5

STASIS :

A low-paced but enervating 360-degree conflict is burning; geographical and social insurgency erupts continually, while Nature and Technology are misused.

THESIS :

The Authoritative prevision demands a World Order in which social conflicts are controlled, technology reoriented, and Nature Respected

S-5 A low-paced but enervating 360-degree conflict is burning; geographical & social insurgency erupts continually; while Nature & Technology are misused.

T-5 The Authoritative prevision demands a WORLD ORDER in which ——— social conflicts are controlled, technology reoriented, & Nature Respected.

6

STASIS :

A pestilence of psychic distress
is spreading among a majority of people
who had progressed to live beyond caloric hunger.

THESIS :

Personal and social health are indivisible;
one and all need a defensible meaning of themselves;
equal chances for life-fulfilling experiences;
and a satisfying system
of adjusting inner and social demands.

S-6
A pestilence of psychic distress is spreading among a majority of people who had progressed to live beyond caloric hunger.

T-6 Personal & Social Health are indivisible; one & all need a defensible meaning of themselves; equal chances for life-fulfilling experiences; & a satisfying system of adjusting to inner & social demands.

7

STASIS :

The Human Personality,
in the richest and poorest countries,
is SCHIZOID, split from the World;
the higher the social responsibility of people,
the greater the tension to split.

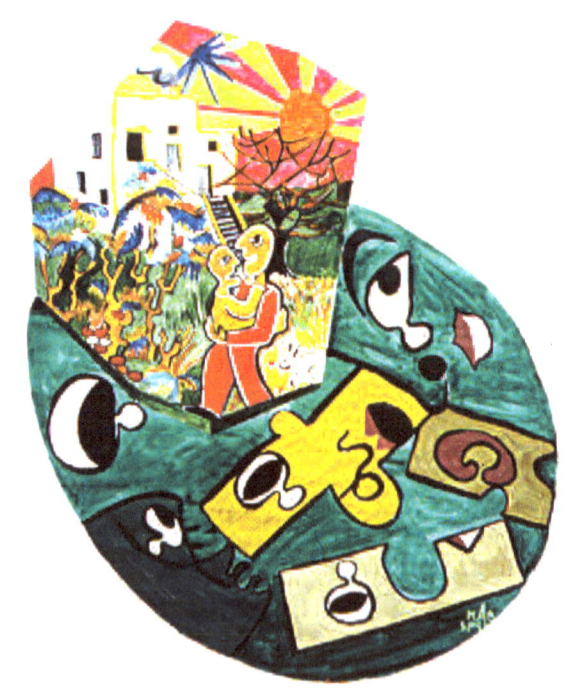

THESIS :

A new identity called EMOS,
comes from universal and particular identifications
of affectionate kind, nurtured by food,
sleep, warmth and healthy care, and by possessions
that extend the personality,
and give it free play upon things.

S-7 The Human Personality in the richest & poorest countries is SCHIZOID, split from the World. the higher the Social Responsibility of people, the greater is the tension to split.

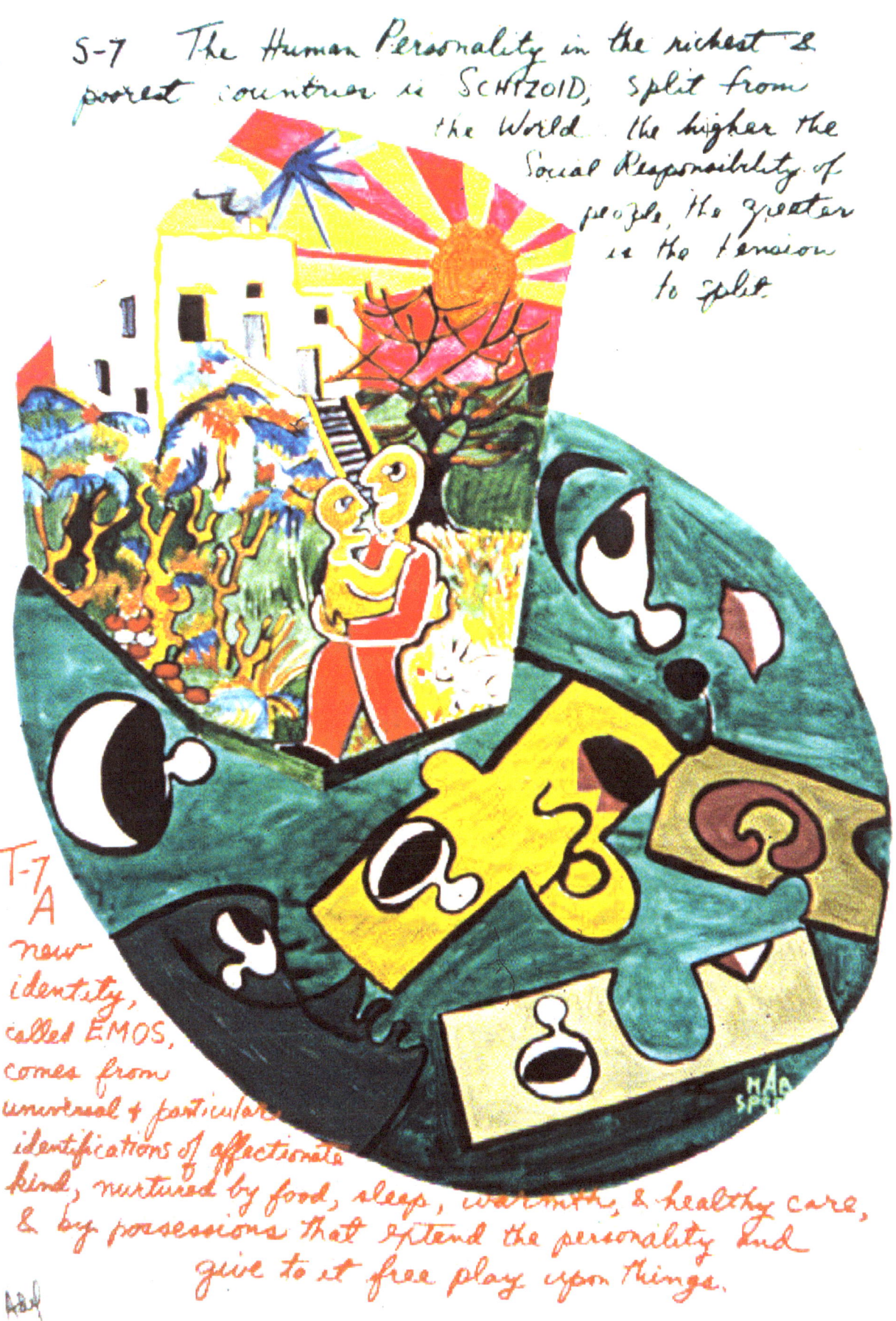

T-7 A new identity, called EMOS, comes from universal & particular identifications of affectionate kind, nurtured by food, sleep, warmth, & healthy care, & by possessions that extend the personality and give to it free play upon things.

8

STASIS:

The distribution of goods is
skewed aimlessly but disastrously,
while the world demand for equality is
petty, naive, and ineffectual.

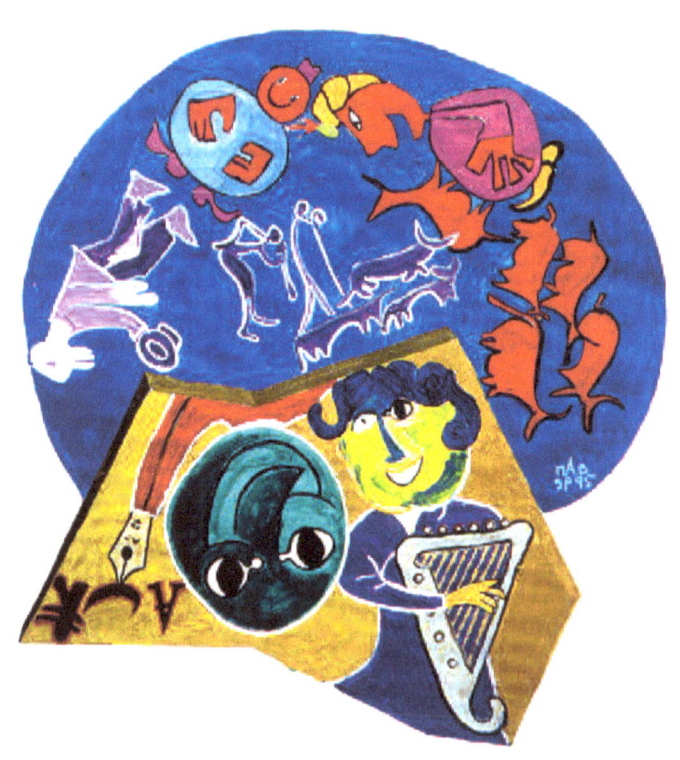

THESIS:

Beyond emos extends the search for experience
-- or PNEUMOS, the questing for self-fulfillment --
that carries a person into the worlds of creativity,
of opportunity beyond security,
of chances at power, wealth, and knowledge,
corresponding to one's character and abilities.

S-8 The distribution of goods is skewed aimlessly but disastrously, while the World demand for equality is petty, naive, & ineffectual.

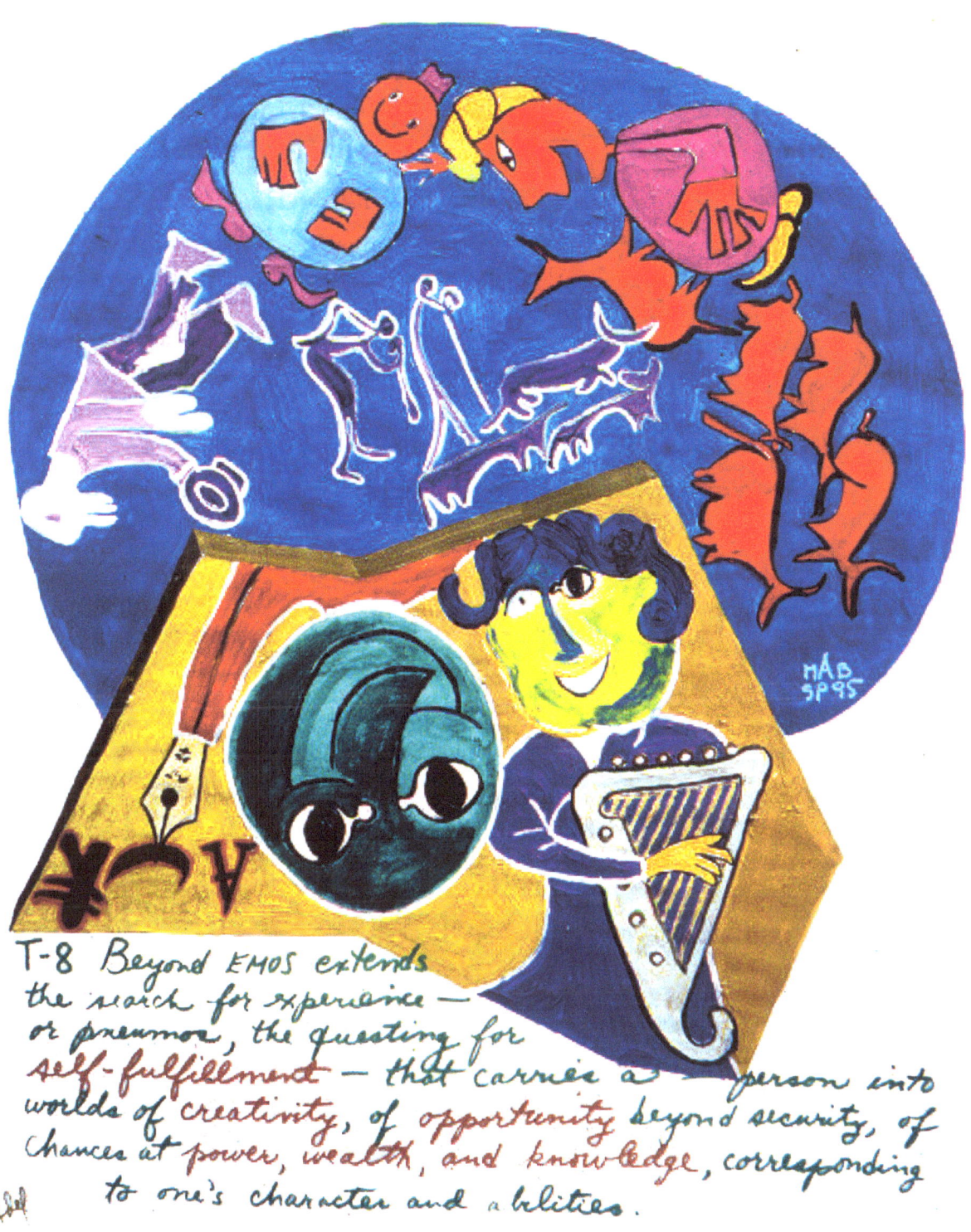

T-8 Beyond EMOS extends the search for experience — or pneumos, the questing for self-fulfillment — that carries a person into worlds of creativity, of opportunity beyond security, of chances at power, wealth, and knowledge, corresponding to one's character and abilities.

9

STASIS:

Out of greed, fear, and ignorance,
not one ruling group in the whole world
espouses policies that are adequate
to the world's urgent needs.

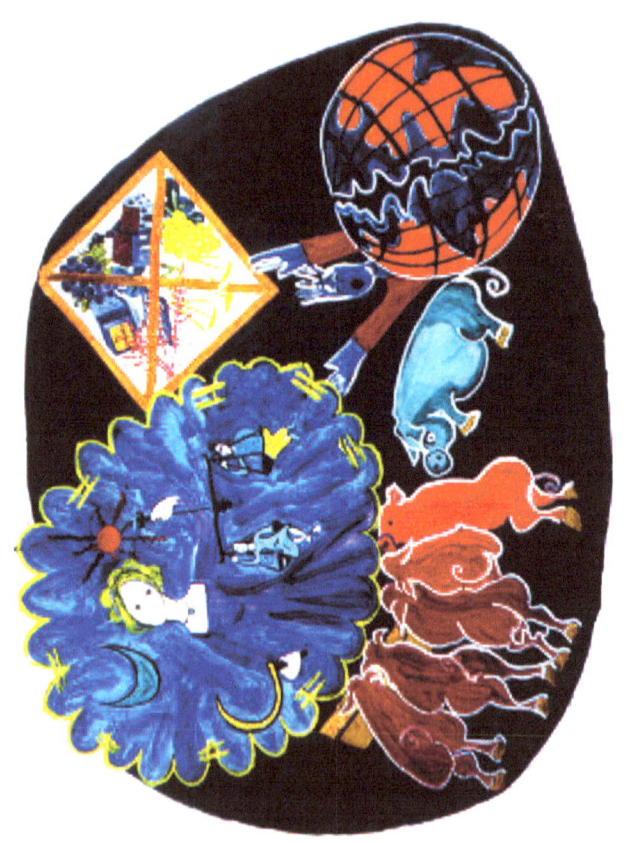

THESIS:

DIKEOS is adjustment and justice
-- inner adjustment, privacy, safety,
the ability to resist restraints,
enjoyment of a rule of law,
satisfying humans in the resolution of
their conflicts within themselves, and with others.

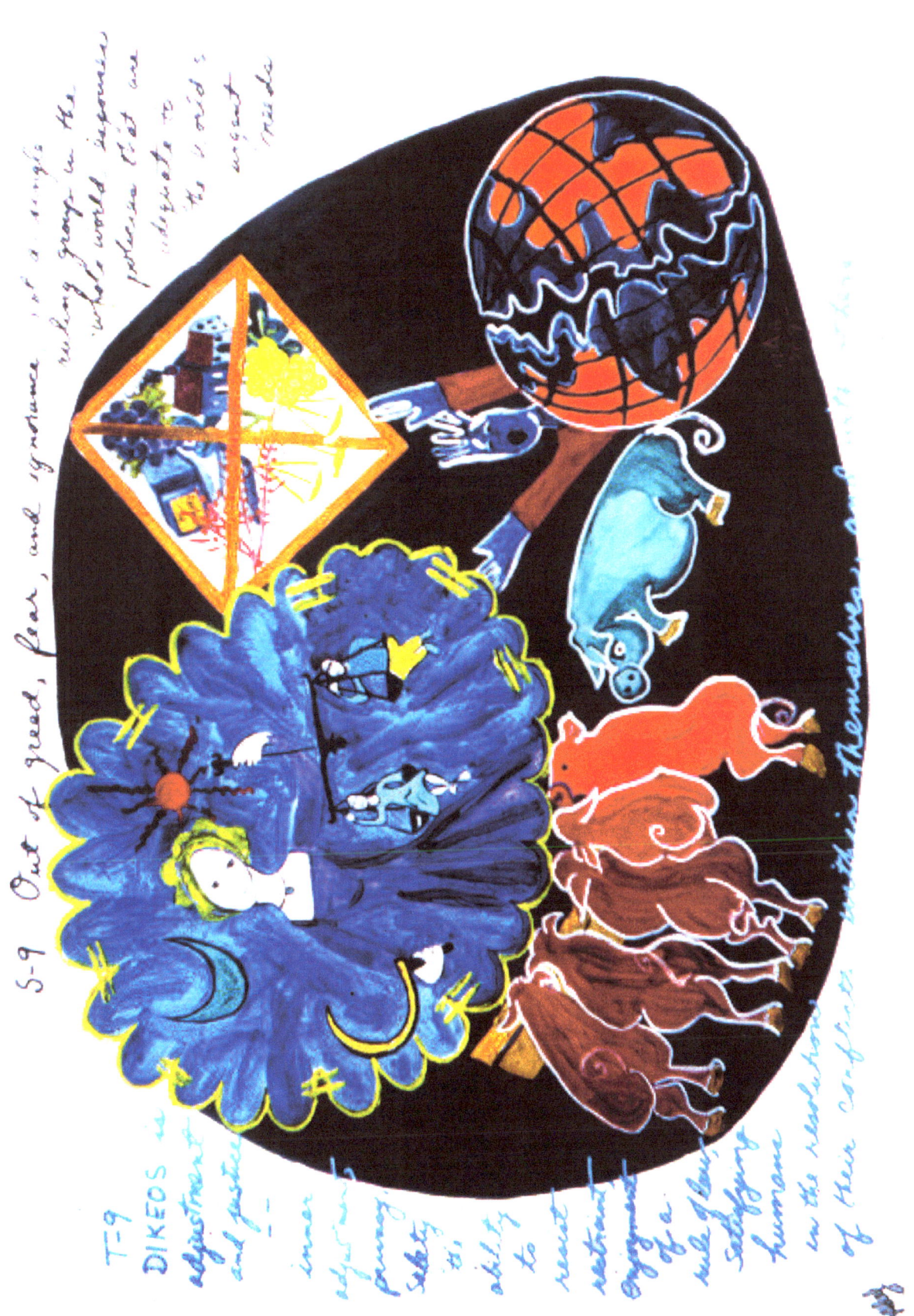

10

STASIS :

The writing of history has conjured up false gods;
historiography is parochial, partial,
enemy of the aspiring young,
consoler of the inept, brutal, and hopeless.

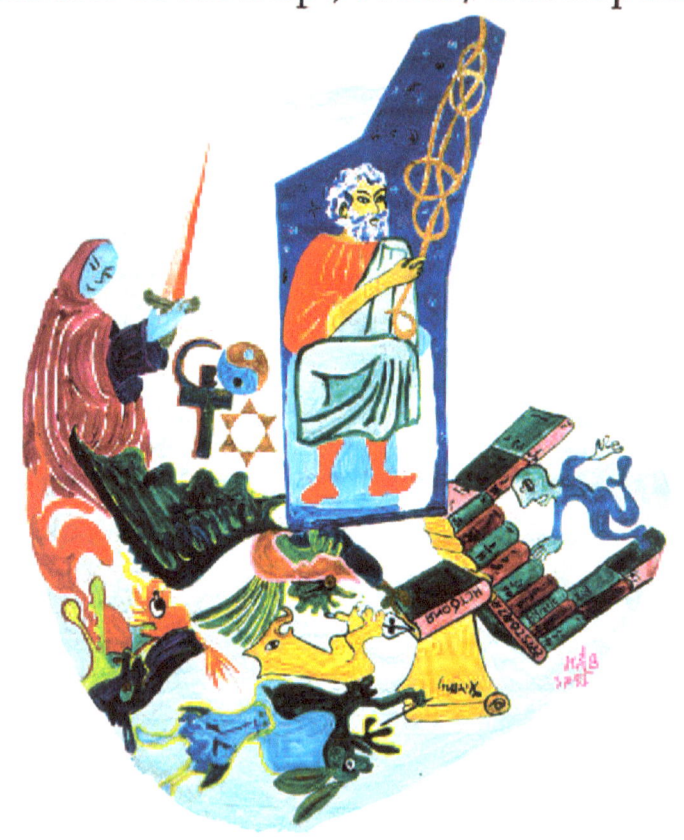

THESIS :

History should teach of problem-solving man,
who has made unending and heroic efforts
on behalf of equality, universality,
benevolence, and humanism;
history should assist
strategy and tactics for the future.

S-10 The writing of history has conjured up false gods; historiography is parochial, partial, enemy of the aspiring young, consoler of the inept, the brutal, the hopeless.

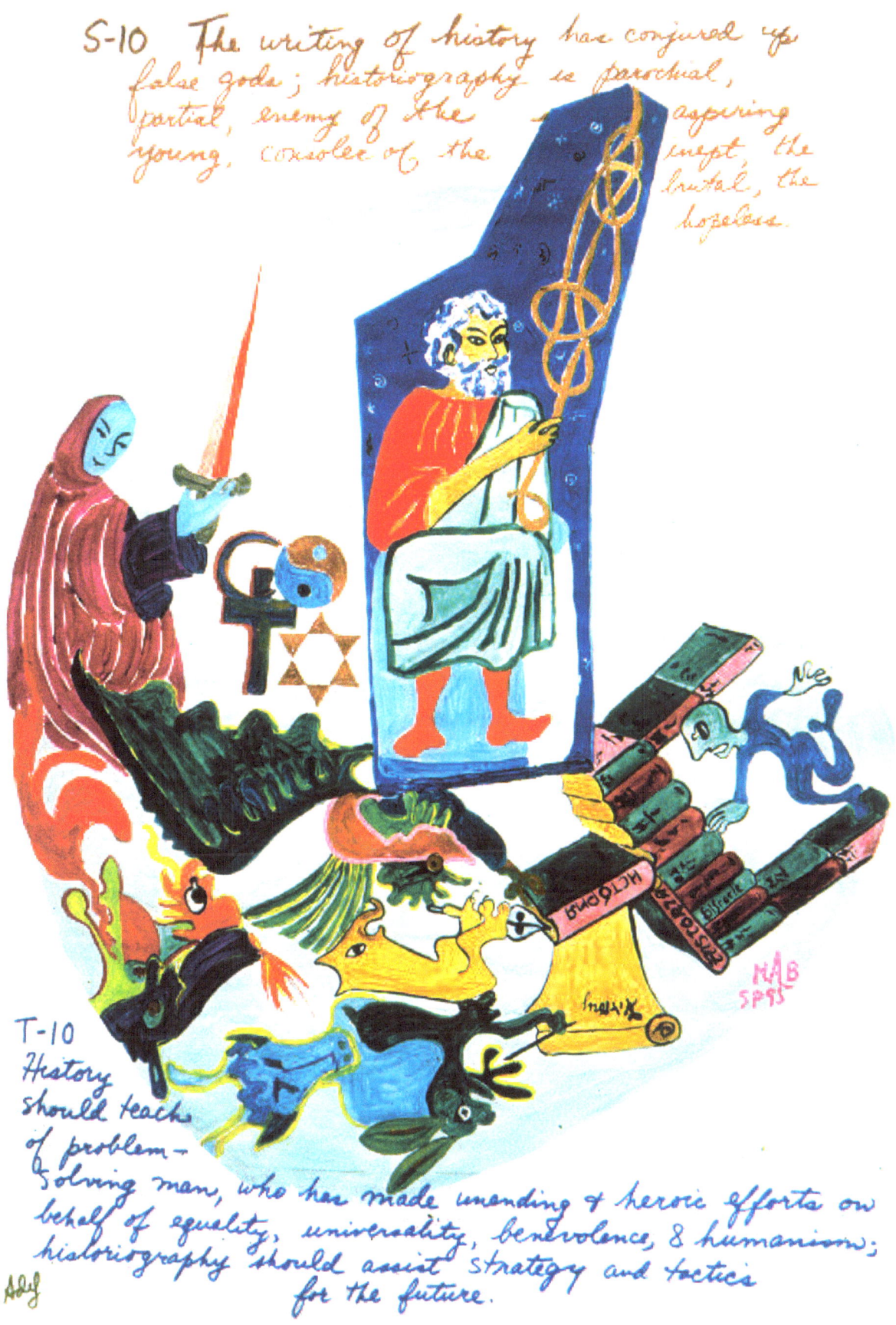

T-10 History should teach of problem-solving man, who has made unending & heroic efforts on behalf of equality, universality, benevolence, & humanism; historiography should assist strategy and tactics for the future.

11

STASIS :

Sick political games are played between
leaders and followers, and called
government of the people, by the people,
and for the people;
the winners are those who can inspire
moral indignation over trivia.

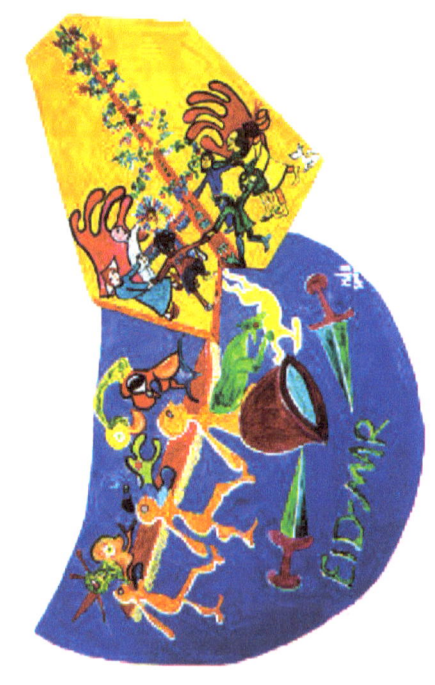

THESIS :

Politics should be free and reasonable cooperation
among all those affected by public policies,
pitched, like history, at the world future,
justifying its issues by the imperatives
of the worst problems.

S-11 Sick political games are played between leaders and citizens, and called government of the people, by the people, and for the people; the winners are those who can suppress their imagination over losses.

T-11 Politics should be free and reasonable cooperation among all those effected by public policy, pitched, like history, at the world future, justifying its issues by the imaginations of the world's worst problems.

12

STASIS:

Existing institutions are sets of Rigid incantations,
containing some valid humanistic procedures,
amidst a tissue of lies
about their real purposes and effects.

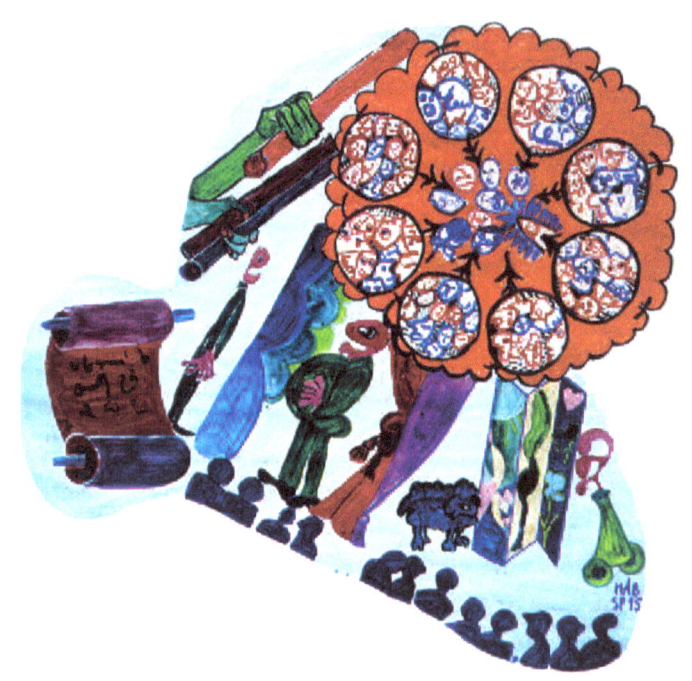

THESIS:

A KALOTIC CONSTITUTION for all human organizations
aims at EMOS, DEMOS, DIKEOS, PNEUMOS, through
instruments of Representative Councils,
Executive Committees, and Judicial Committees;
access to governance is full, expression free,
coercion is strictly restricted, accretions of power
without excretions of equal power are banned.

S-12 Existing institutions are sets of Rigid Incantations containing some valid humanistic procedures, amidst a tissue of lies and myth about their real purposes & effects.

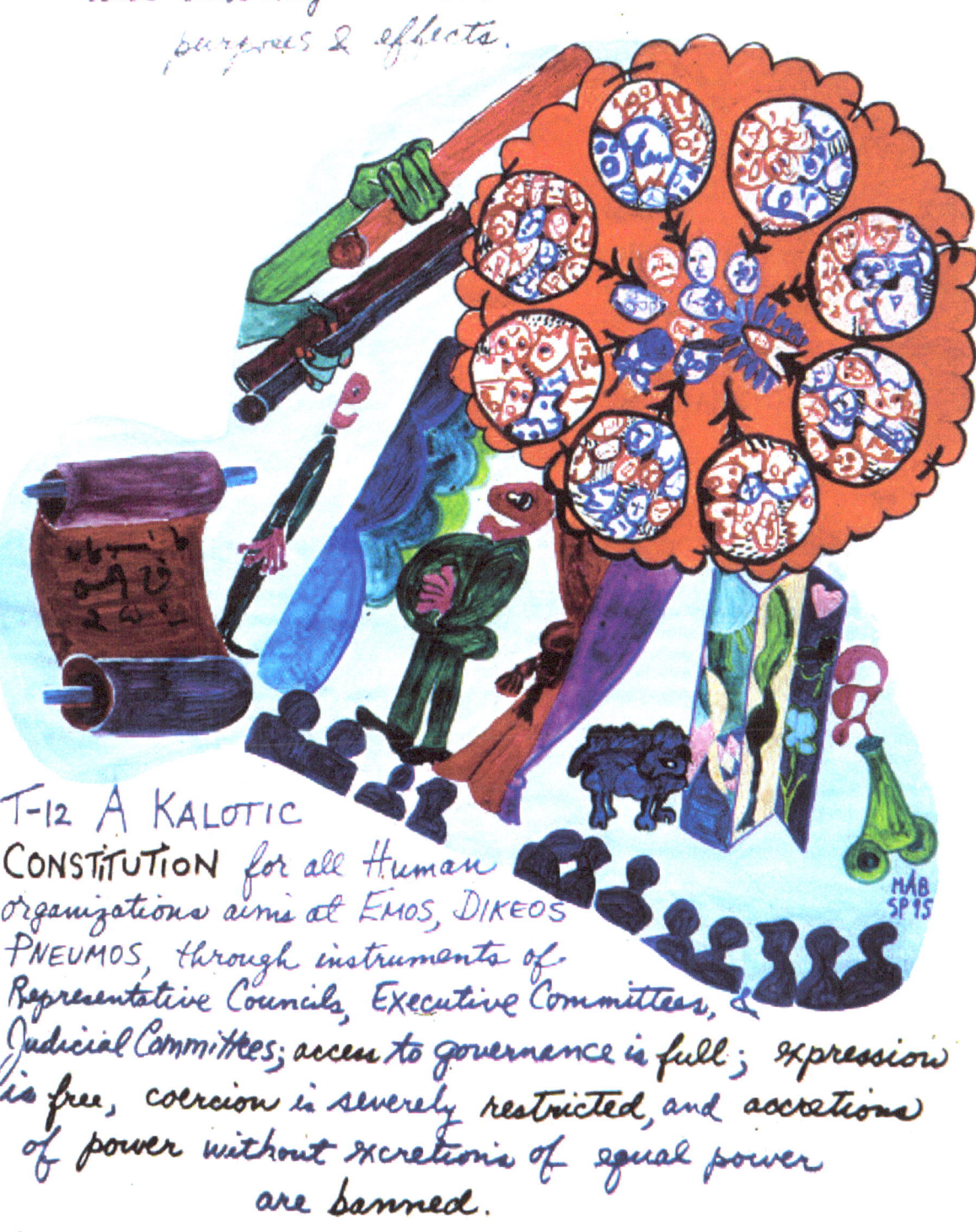

T-12 A KALOTIC CONSTITUTION for all Human organizations aims at EMOS, DIKEOS, PNEUMOS, through instruments of Representative Councils, Executive Committees, & Judicial Committees; access to governance is full; expression is free, coercion is severely restricted, and accretions of power without excretions of equal power are banned.

Adef

13

STASIS:

Representation of humans in circles of power
is partial and fragmentary,
while possibilities of their representation derided,
though unknown.

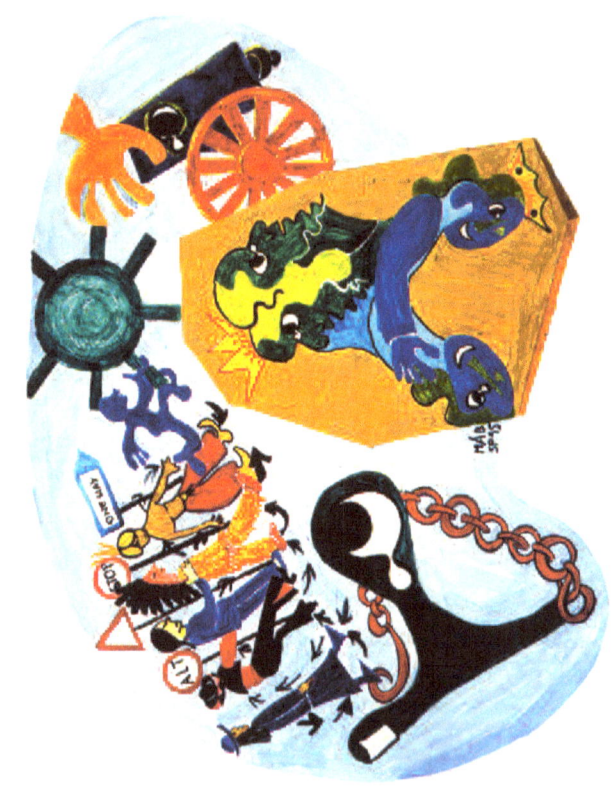

THESIS:

Each large group should be a representative government,
operating under a behaviorally meaningful Constitution,
in which every member should be
a responsible ruler
as well as a responsible subject.

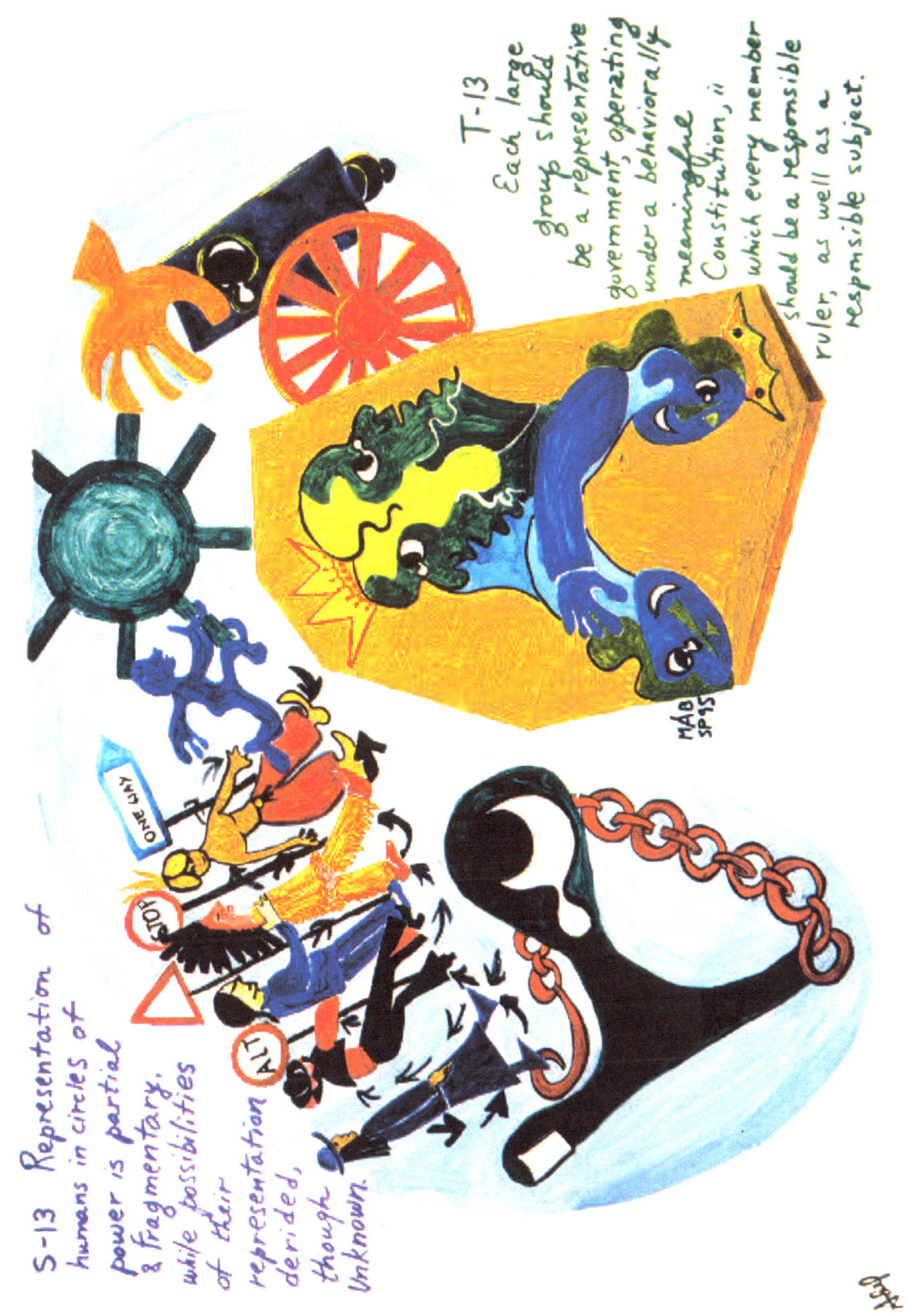

S-13 Representation of humans in circles of power is partial & fragmentary, while possibilities of their representation derided, though unknown.

T-13 Each large group should be a representative government operating under a behaviorally meaningful Constitution, in which every member should be a responsible ruler, as well as a responsible subject.

14

STASIS:

All institutions block each other and the ultimate goals of society:
labor unions block productivity, owners blocks human credit,
agencies block personal initiative, churches block family reform,
families block education, suburbs block cities,
men block women --
ALL EQUALS GLOBAL FRUSTRATION.

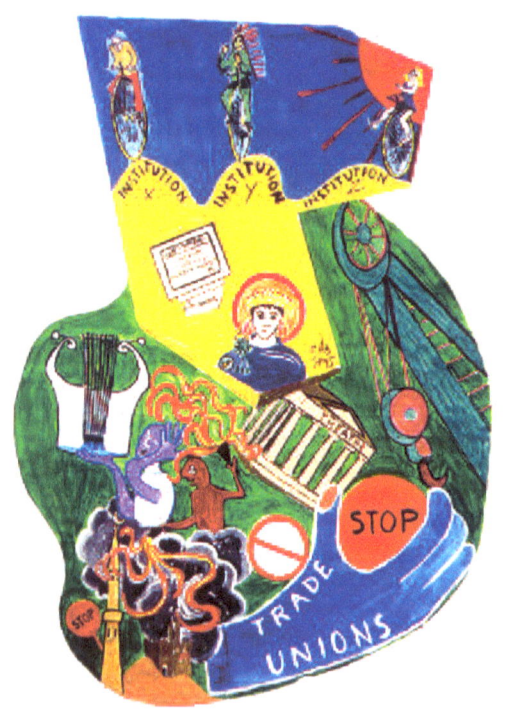

THESIS:

All institutions require reform, internally, operationally,
administratively, and in regard to external clienteles;
modern design science can create new institutions easily,
freely, flexibly, cheaply, quickly,
as patterns of conduct pursuing goals.

S-14 All institutions block each other & the ultimate goals of society: labor unions block productivity, owners block human credit, agencies block personal initiative, churches block family reform, families block education, suburbs block cities, men block women, — ALL EQUALS GLOBAL FRUSTRATION. ALL EQUALS GLOBAL FRUSTRATION.

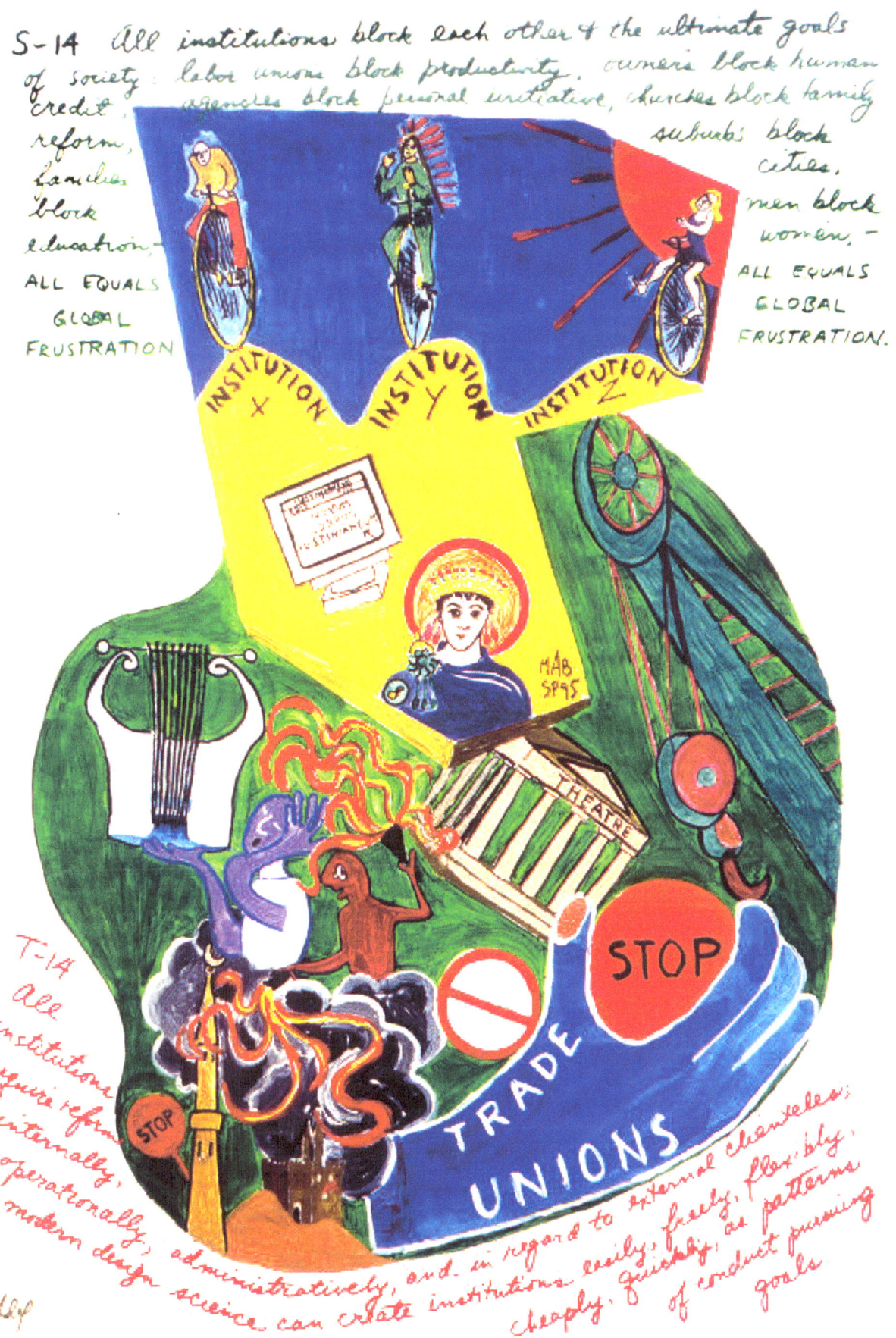

T-14 All institutions require reform, internally, operationally, administratively, and in regard to external clienteles; modern design science can create institutions easily, freely, flexibly, cheaply, quickly; as patterns of conduct pursuing goals.

15

STASIS :

Family relations are chaotic and retarding;
although the typical family everywhere is sexist,
authoritarian, and stripped of effective functions
by society and technology;
people stay with it because of compulsion,
sickness, dependency, and lack of anywhere to go.

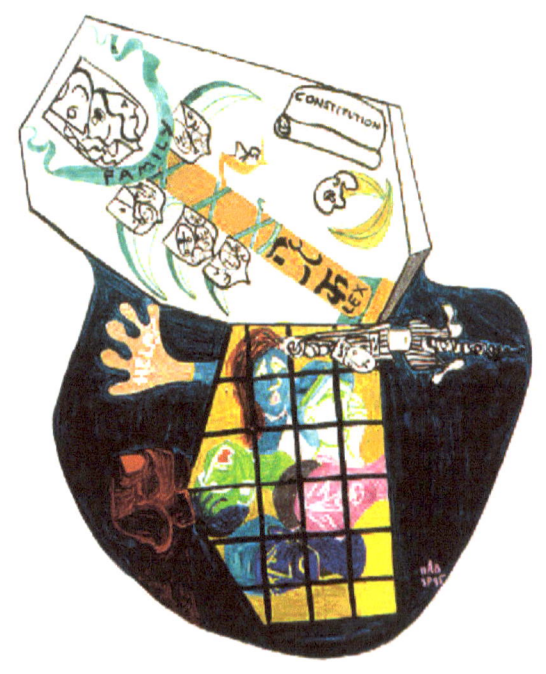

THESIS :

The Family must be a Constitutional organ,
rehearsing later life;
its members need equal chances to express their qualities,
to elect membership beyond the age of fourteen;
they should be secure financially,
and need extensive neighborly affinities.

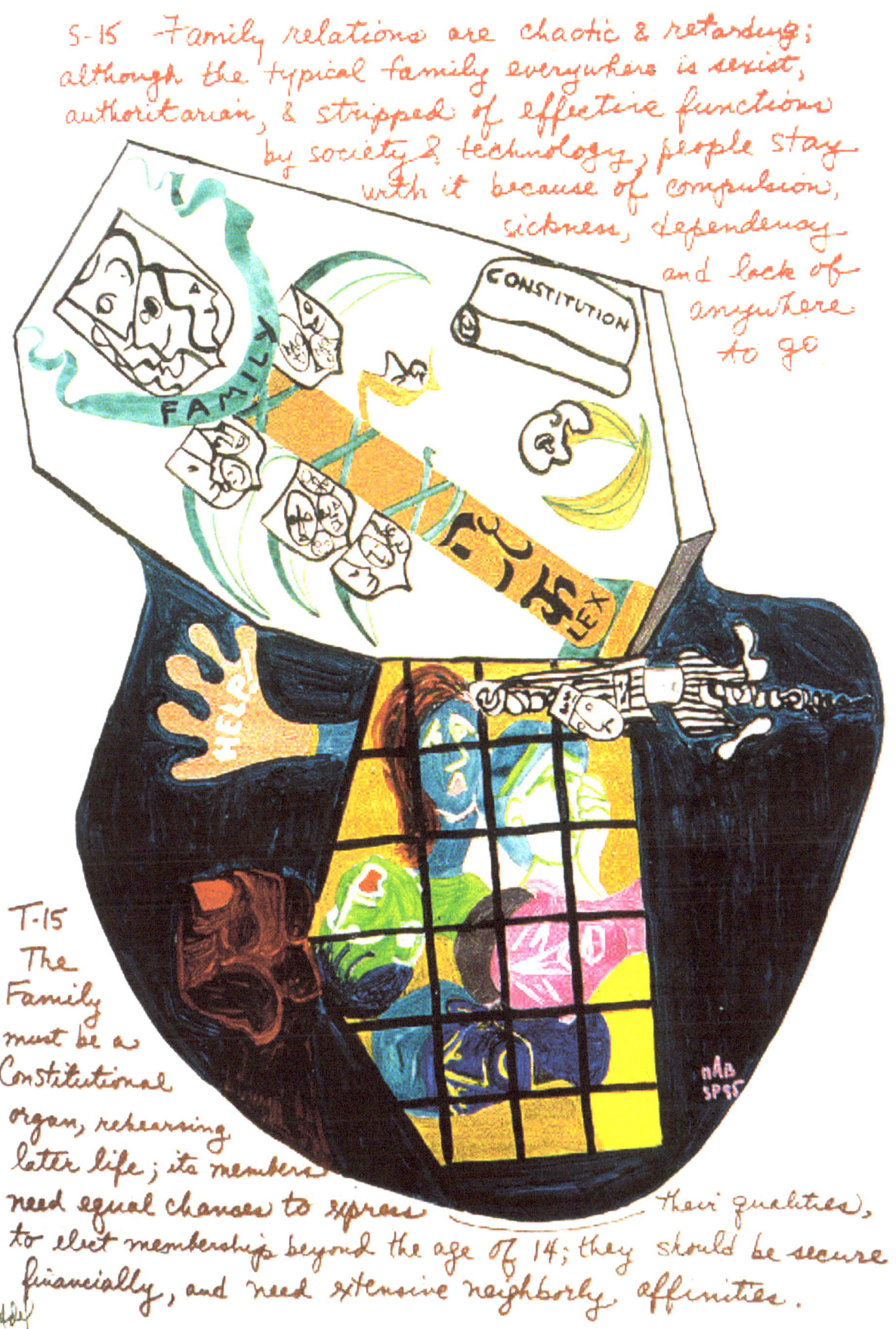

S-15 Family relations are chaotic & retarding; although the typical family everywhere is sexist, authoritarian, & stripped of effective functions by society & technology; people stay with it because of compulsion, sickness, dependency, and lack of anywhere to go.

T-15 The Family must be a Constitutional organ, rehearsing later life; its members need equal chances to express their qualities, to elect membership beyond the age of 14; they should be secure financially, and need extensive neighborly affinities.

16

STASIS :

SCHOOLS on all levels are mismanaged PENS,
maintained peripherally for transmitting knowledge,
but directly for disciplining wants, restraining liberties,
combatting new ideas, and keeping people
from crowding into other troubled areas of life.

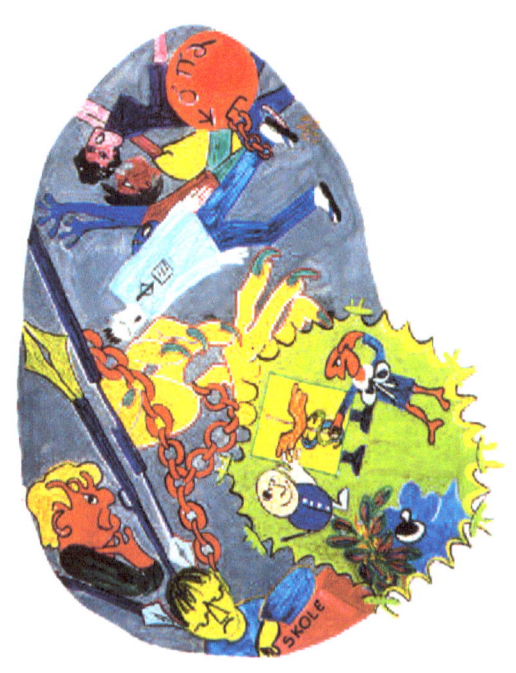

THESIS :

Schools are major rallying places for revolution,
as they are for conserving
whatever should be kept of society;
they should be voluntary associations
formed at all stages of life,
and oriented to the future pragmatically.

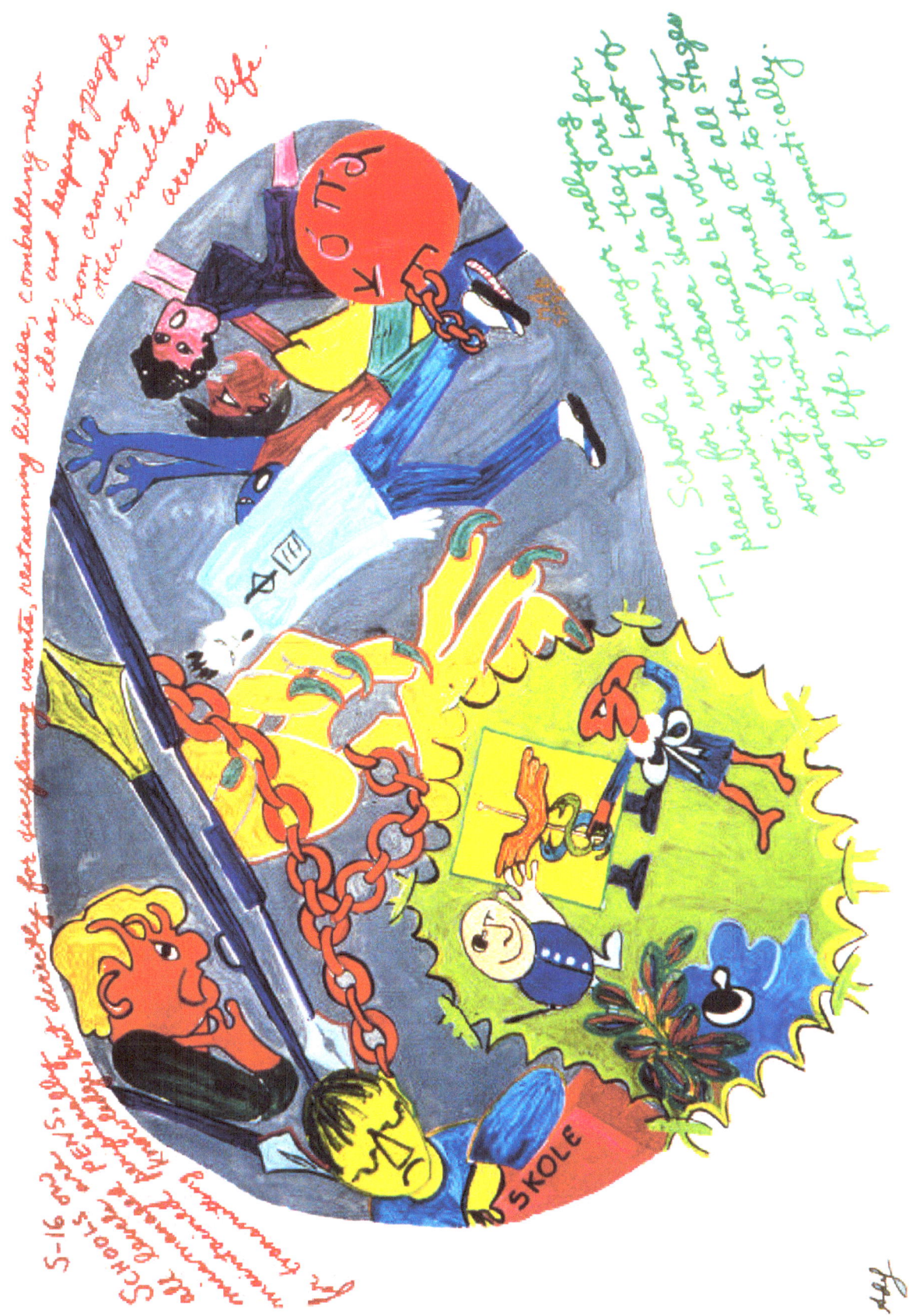

S-16 organisations directly for disciplining wants, restraining libertes, combatting new ideas, are keeping people from crowding into other troubled areas of life. Schools are popularly recognized as communal kindergartens.

T-16 Schools are a major rallying place for revolution, whatever they are for or against; they should be voluntary at all stages concerning their members; they should be kept at a pragmatically society?), formed and oriented to the association, and future of life.

17

STASIS :

Advanced economies are exercises in futility,
their vaunted productivity being a temporary progress
plus a promise, both of which are being negated
by misuse of resources, inflation,
delusory social accounting, heavy costs
that counteract progress and disdain priorities.

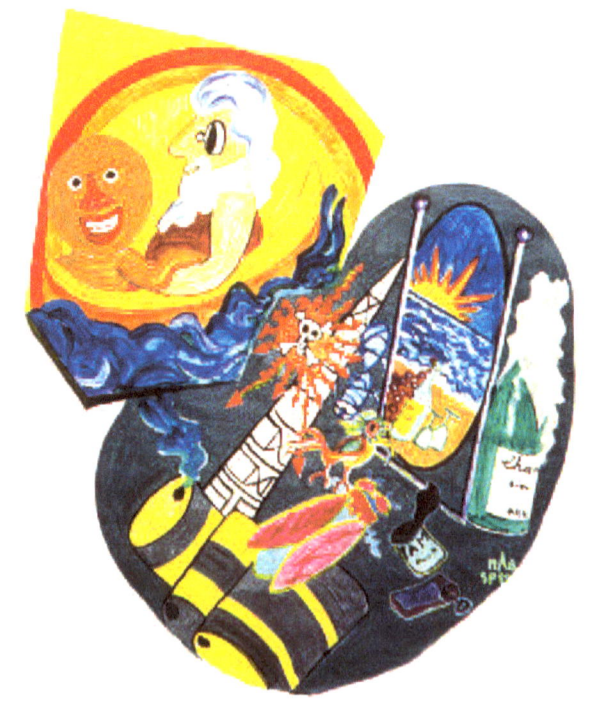

THESIS :

Every person has worth,
and the task of economics is to capitalize this worth;
the first leap everywhere is a womb-to-tomb
disposable life-credit that is paid out and paid back
throughout life,
until death casts the balance forgiven.

S-17 Advanced economies are exercises in futility, their vaunted productivity being a temporary progress, plus a promise, both of which are being negated by misuse of resources, inflation, delusory social accounting, heavy costs that counteract progress and disdain priorities.

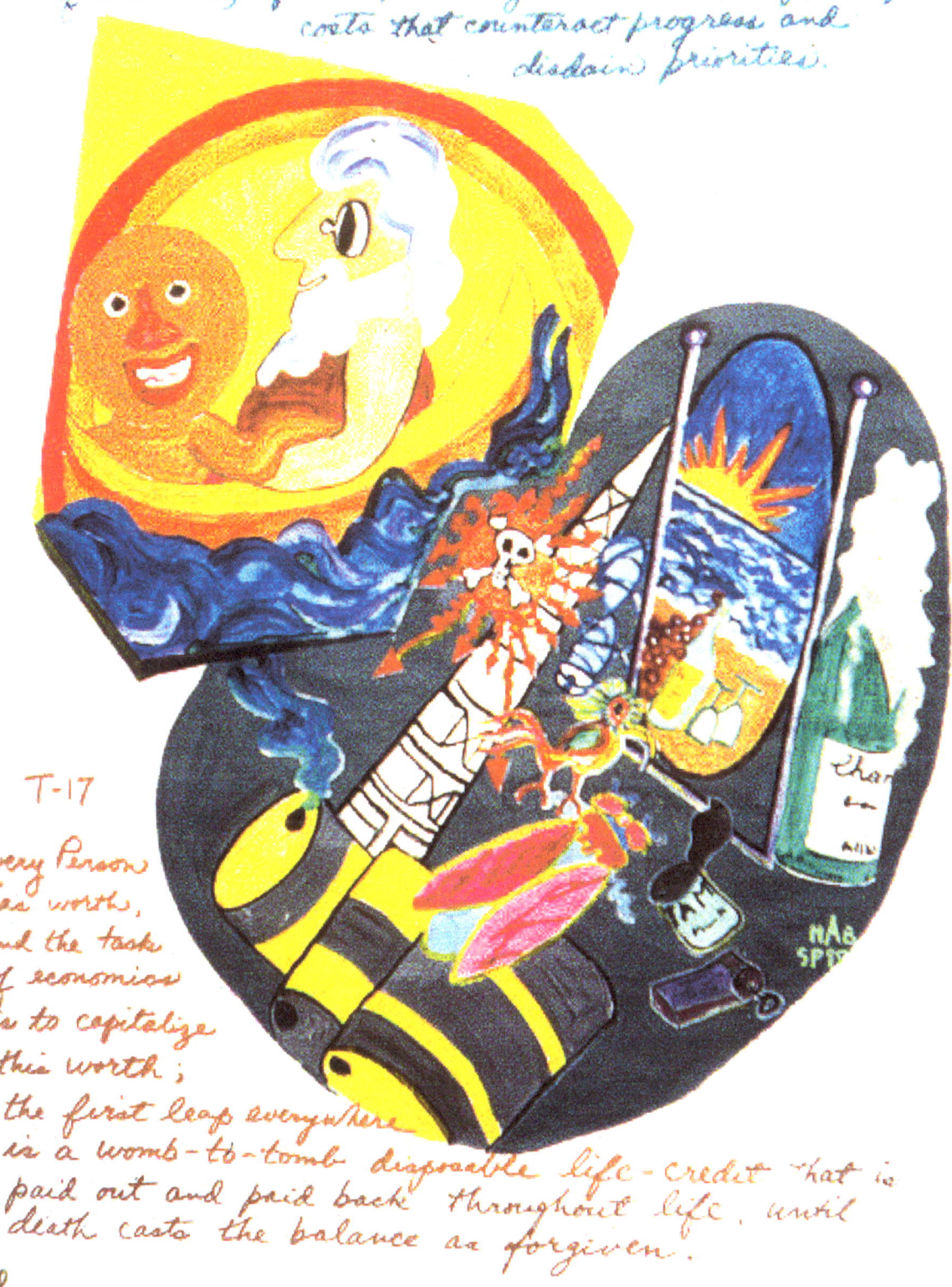

T-17

Every Person has worth, and the task of economics is to capitalize this worth; the first leap everywhere is a womb-to-tomb disposable life-credit that is paid out and paid back throughout life, until death casts the balance as forgiven.

18

STASIS :

Corporations, paramount organizations in all economies,
dealing with all tasks that are not specially innovative,
lack coordination and internal morale, are socially adrift,
steering the world on an unknown course,
justified by a false log of profit.

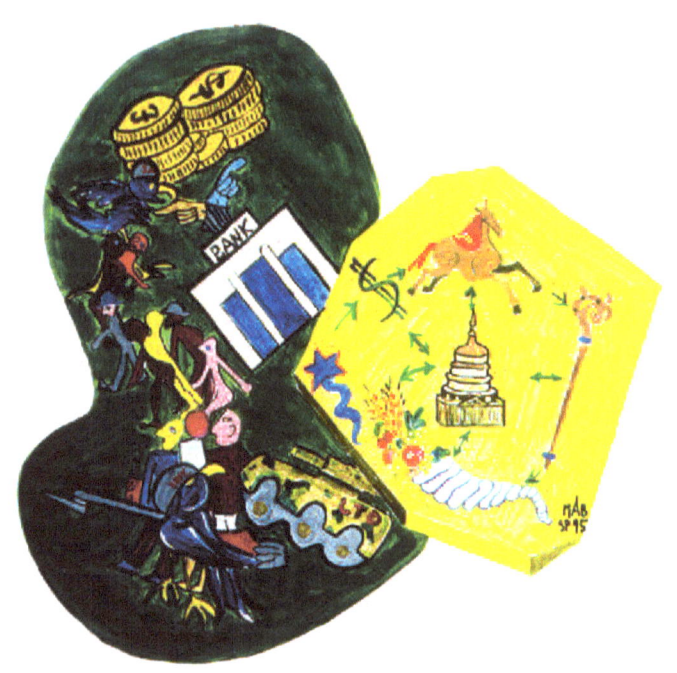

THESIS :

Corporations should be owned and governed
by their fund-capitalists
and worker-capitalists,
and oriented to public purposes and priorities
by these in cooperation with
public representatives.

S-18 Corporations, paramount organizations in all economies, dealing with all tasks that are not especially innovative, lack coordination and internal morale, are socially adrift, steering the World on an unknown course, justified by a false log of profit.

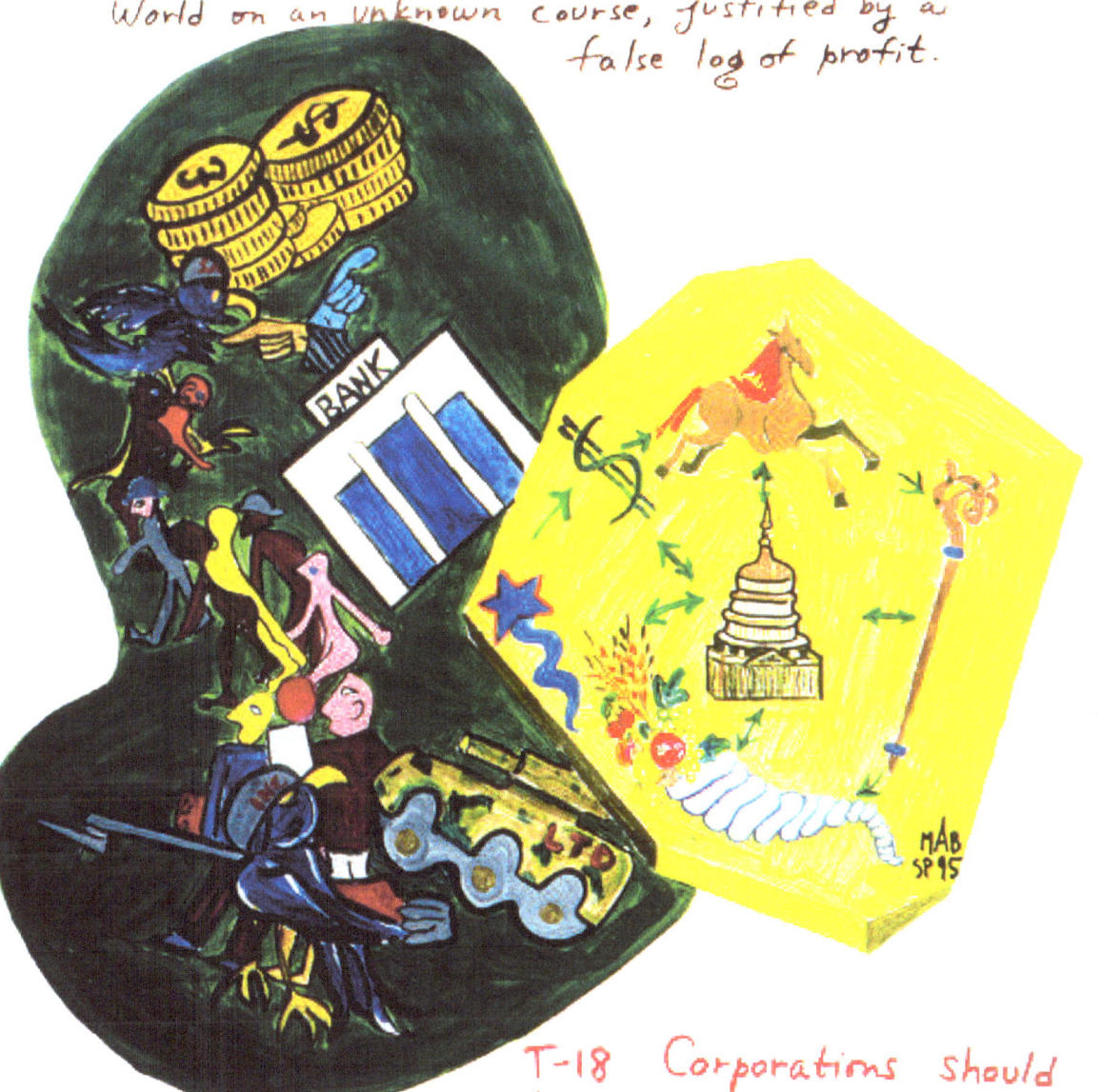

T-18 Corporations should be owned and governed by their fund-capitalists and worker-capitalists, and oriented to public purposes and priorities by these, in cooperation with public representatives.

19

STASIS :

Taxocracy envelops all countries, regardless of their myths,
through rule by impersonal officials, hierarchically arranged,
which, whether governmental or corporate,
is a response to Personal and collective insecurity,
external threats, collective envy,
restricting each person's values, preventing his release
of directed energies and inventions.

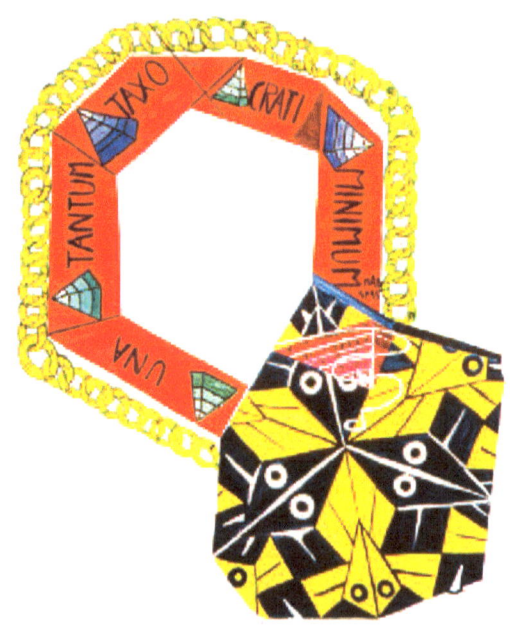

THESIS :

Taxocracy should be limited internally
by regular turnover in office, by countervailing
critics professionally equipped to take a negative view of it,
and by full representative government
employing subordinates as well as clientele;
taxocracy has to be limited externally by decentralization,
generational reconstitution, and inventions
of substitute processes and formations.

through rule by impersonal officials, hierarchically arranged, which, governmental or corporate, is a response to personal and collective insecurity, external threats, collective envy, restricting each person's values, preventing one's release of directed energies and inventions

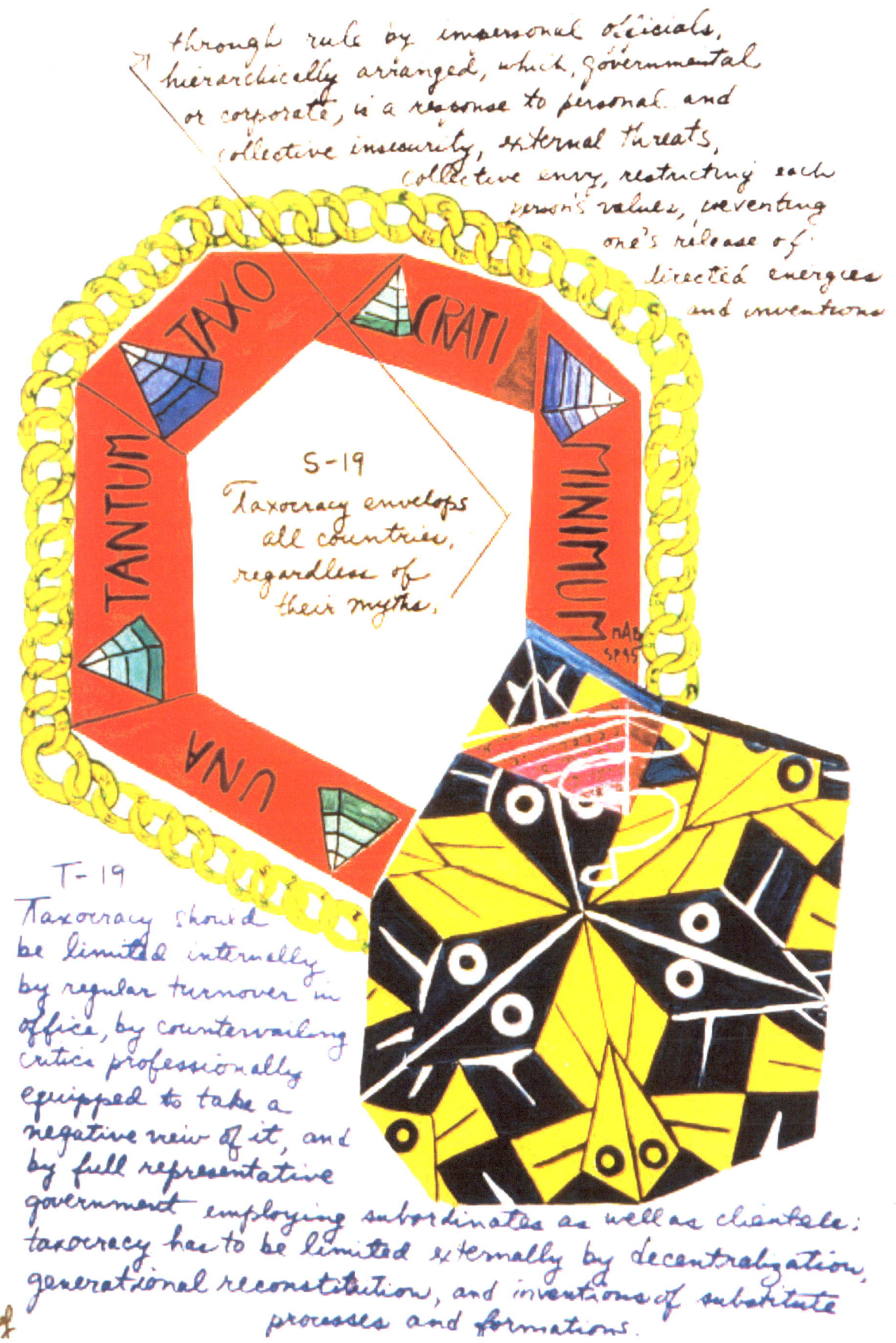

S-19
Taxocracy envelops all countries, regardless of their myths.

T-19
Taxocracy should be limited internally by regular turnover in office, by countervailing critics professionally equipped to take a negative view of it, and by full representative government employing subordinates as well as clientele; taxocracy has to be limited externally by decentralization, generational reconstitution, and inventions of substitute processes and formations.

20

STASIS :

Militarism prospers at the expense of real solutions
and international peace, lending machos to souls,
glamour to taxocrats, security to liberalism,
aggressiveness to the deprived.

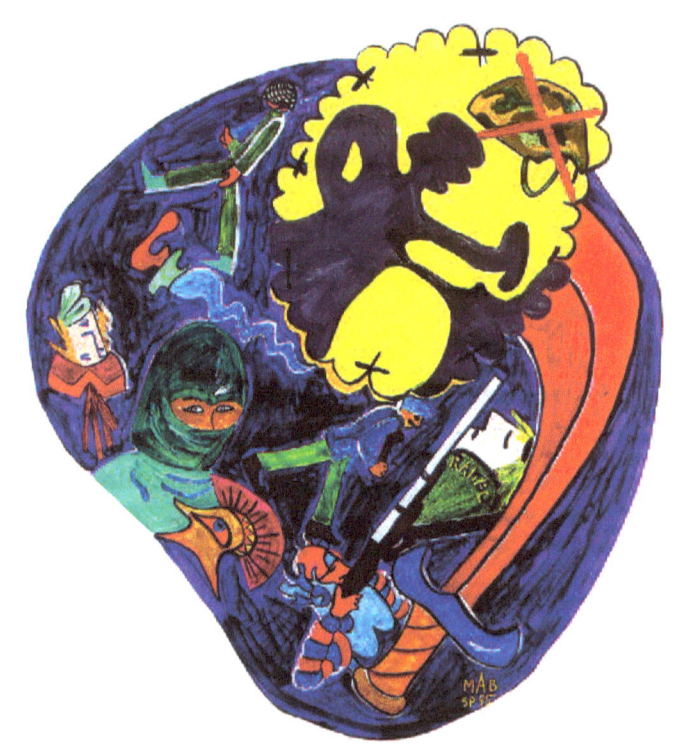

THESIS :

The dissolution of armies is possible
if a movement conveys practical assurances
of well-being and order,
then offers itself;
armed forces should then
convert to kalotic civil task forces.

S-20 Militarism prospers at the expense of real solutions & international peace, lending machoe to souls, glamour to taxocrats, security to liberals, & aggressiveness to the deprived.

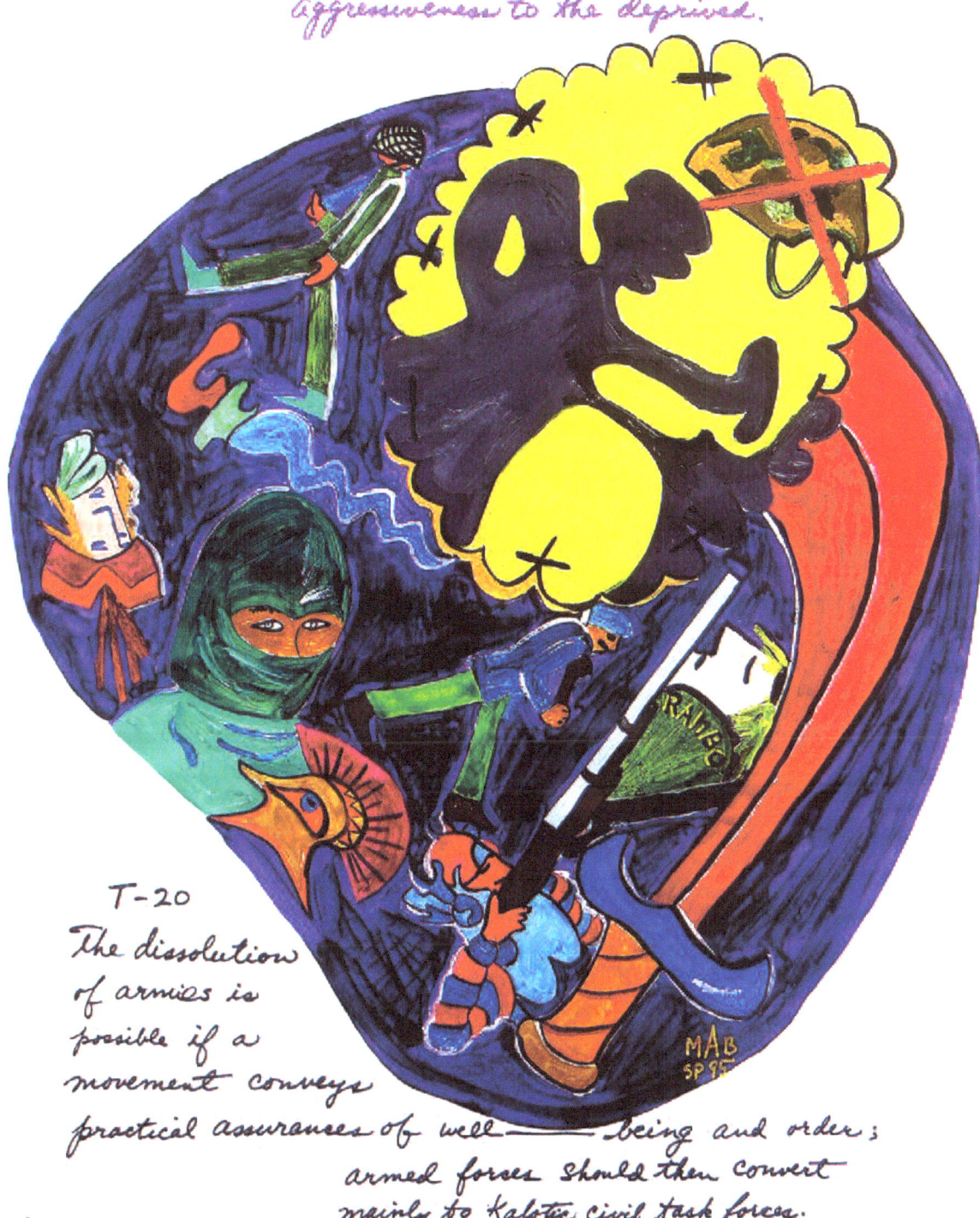

T-20 The dissolution of armies is possible if a movement conveys practical assurances of well-being and order; armed forces should then convert mainly to Kalotic civil task forces.

Adef

21

STASIS:

Paleo-poverty, affecting a fifth
of the rich countries' people,
and nine-tenths of the people of poor countries,
is technologically outmoded,
but the politics of poverty
as a struggle over sin remains in vogue.

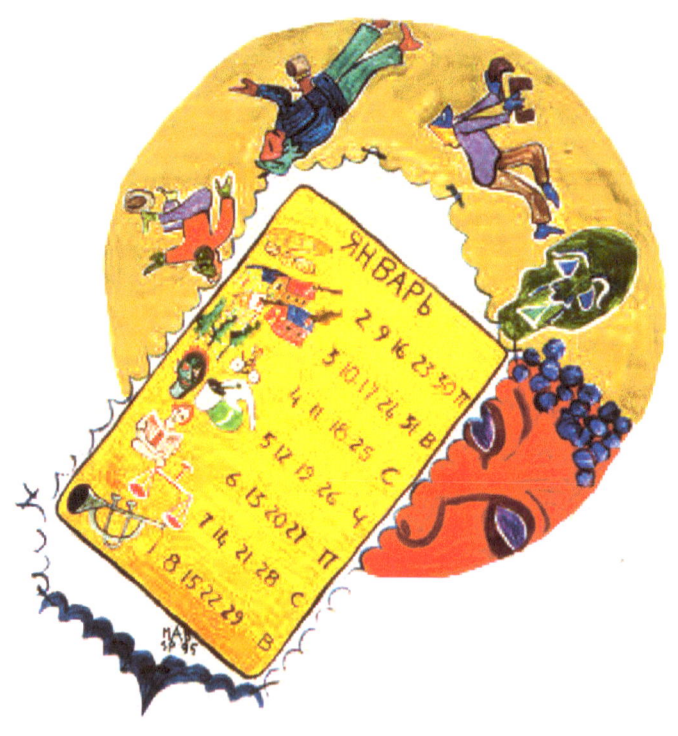

THESIS:

All countries should constitute
life-account systems for all,
to assure a guaranteed minimum
annual income to everybody;
this, aided affordably by the richer countries,
will eliminate paleo-poverty.

S-21 Paleo-poverty, affecting a fifth of the rich countries' peoples, and nine-tenths of the people of poor countries, is technologically outmoded, but the politics of poverty as a struggle over sin remains in vogue

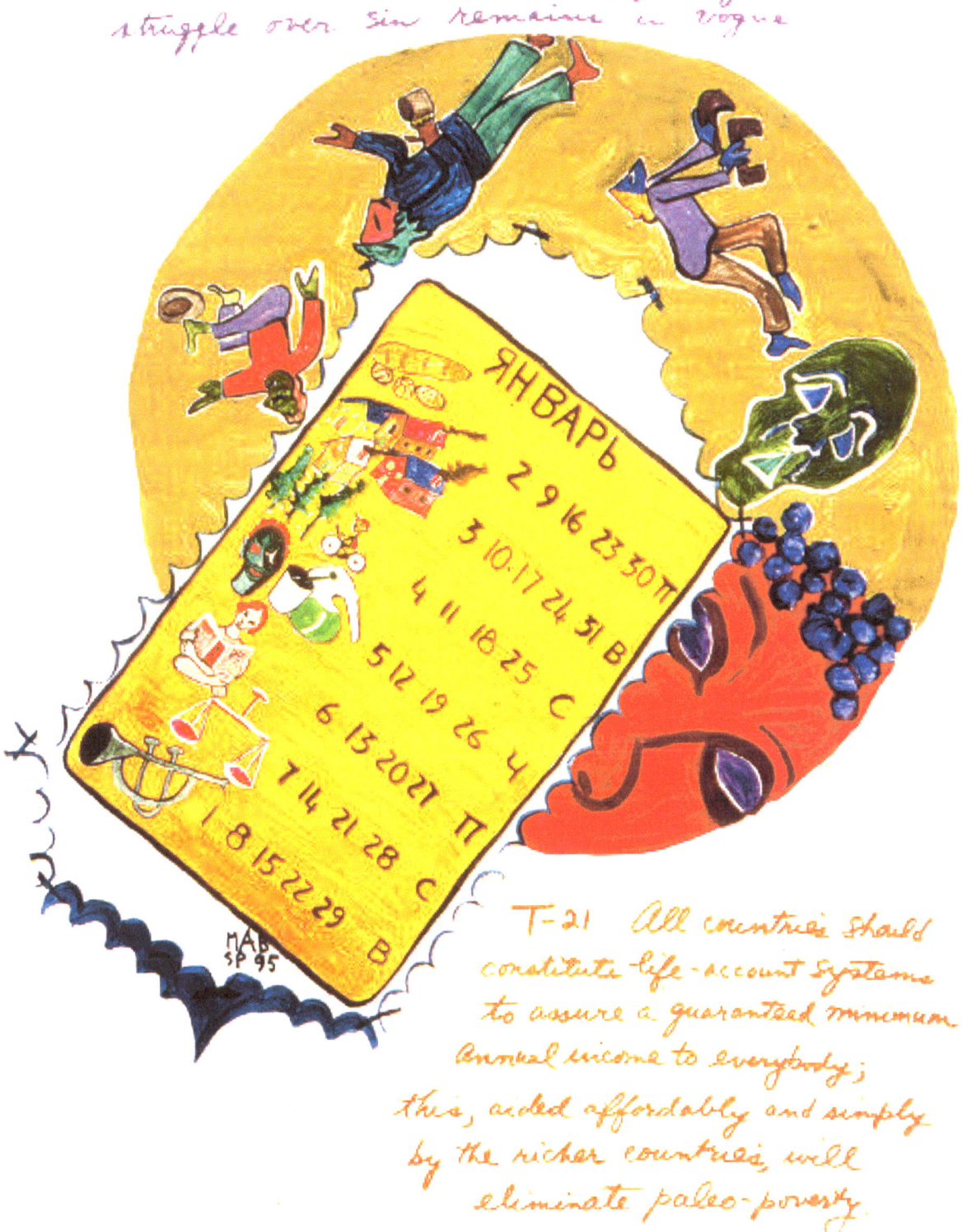

T-21 All countries should constitute life-account systems to assure a guaranteed minimum annual income to everybody; this, aided affordably and simply by the richer countries, will eliminate paleo-poverty.

22

STASIS :

The rich of plutocracies & taxocracies are exhausted
by the complexities and demands of economies
that promise them material completion,
but really divert them from humane goals
and plunge them into neo-poverty
of psycho-economic distress.

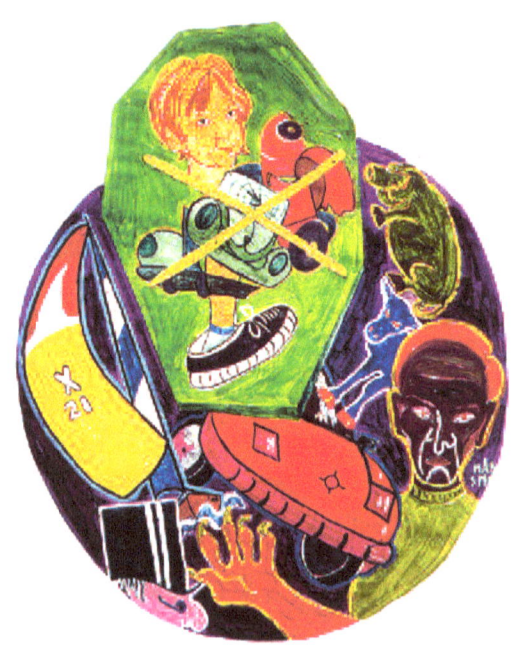

THESIS :

Elimination of neo-poverty needs a revolution
of life-style, a denial of popular consumption patterns,
plus a diversion of 70% of dysfunctional production
of world plutocracies, to eliminate paleo-poverty
and provide a richer life to pseudo-beneficiaries
of technologized economies.

S-22 The rich of plutocracies and taxocracies are exhausted by the complexities and demands of economies that promise them material completion, but really divert them from humane goals, and plunge them into the neo-poverty of psycho-economic distress.

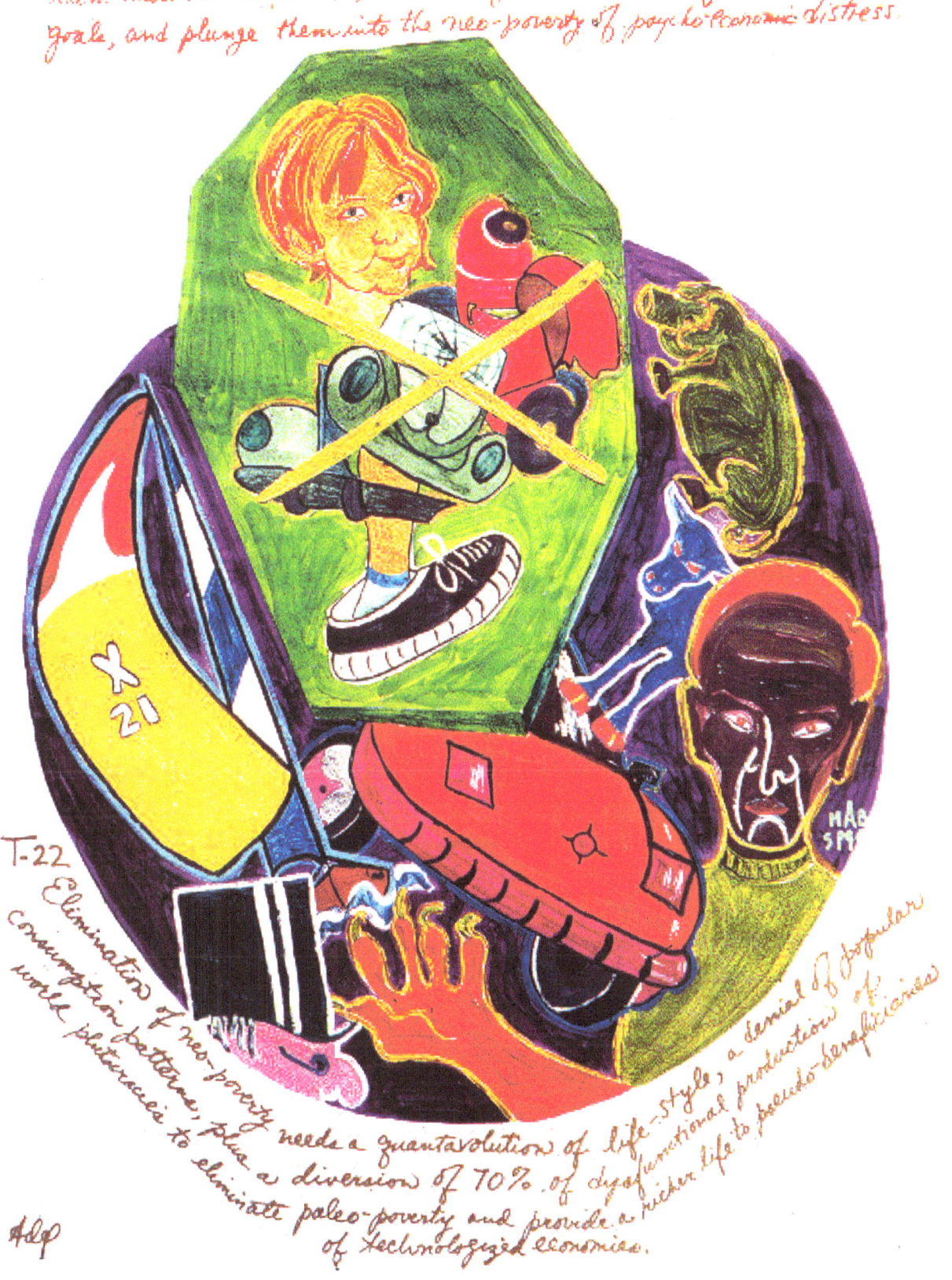

T-22 Elimination of neo-poverty consumption patterns; plus a diversion of 70% of dysfunctional production of world plutocracies to eliminate paleo-poverty and provide a richer life to pseudo-beneficiaries needs a quantavolution of life-style, a denial of popular of technologized economies.

Adp

23

STASIS :

The poor countries are retrogressing,
their agriculture is hardly needed with industrial farming,
inventions of new varieties and processes;
their environments are degenerating, their resources dwindling;
their manufactures cannot compete;
they fall ever deeper into debt
despite privatizing and nationalizing.

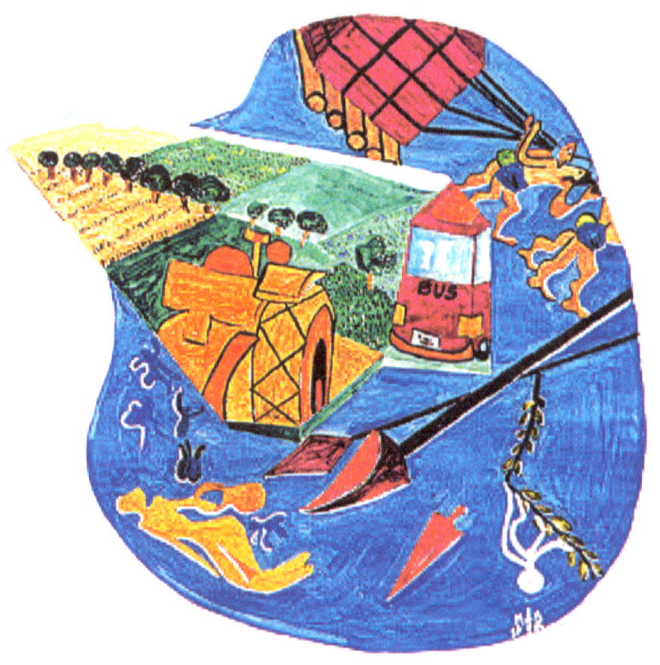

THESIS :

A world organ is needed to capitalize & implant automated
consumer industries in poor countries;
rurality and its farming patterns need replacement
(not re-establishment); with fast transport and all communications,
rurality works best as decentralized work stations,
part-time residences and retirement places
for urbanites of all income levels.

S-23 The poor countries are retrogressing; their agriculture is hardly needed with industrial farming, inventions of new varieties and processes; their environments are degenerating, their resources dwindling; their manufactures cannot compete; they fall ever deeper into debt despite privatizing and nationalizing.

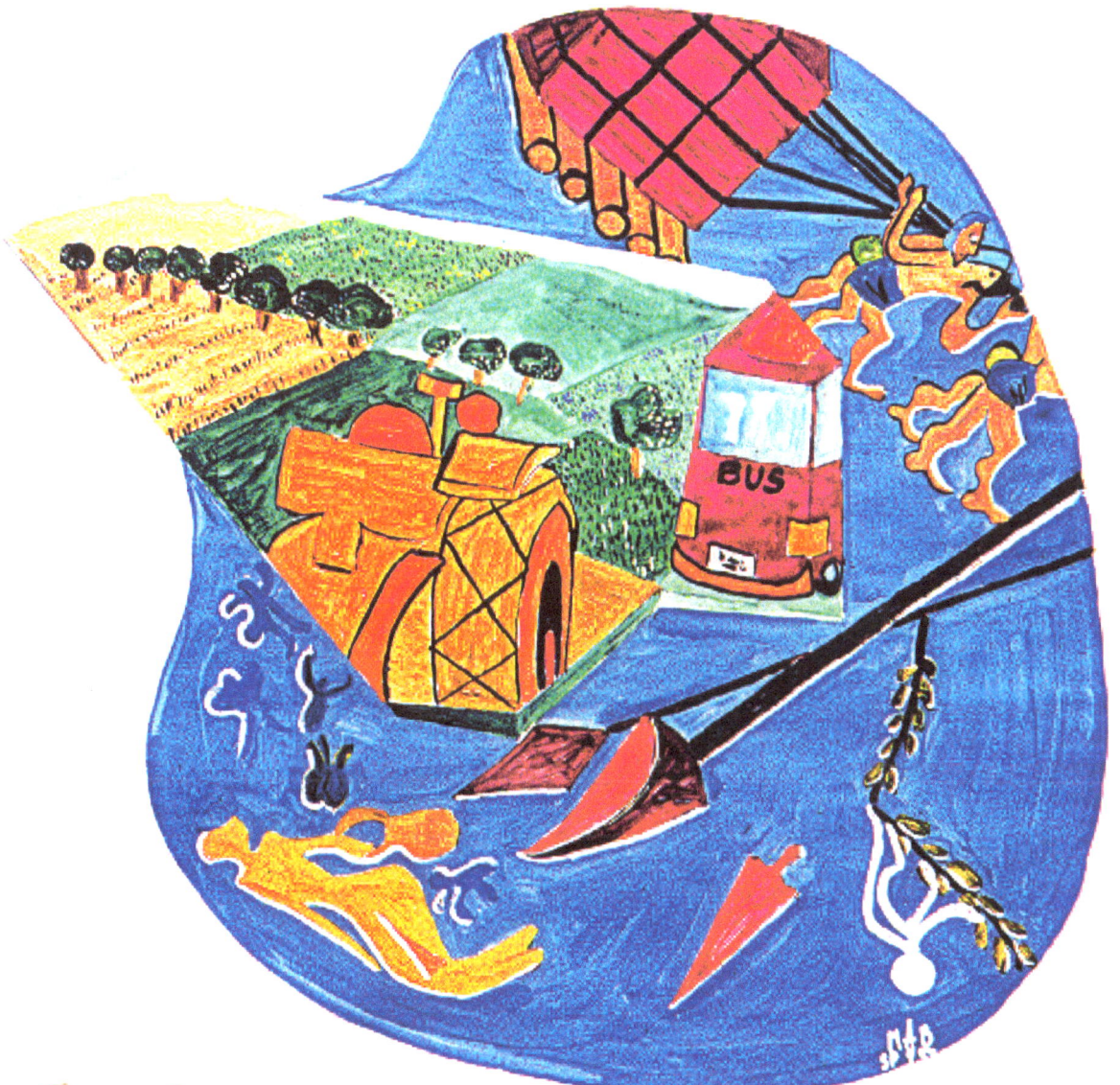

T 23 A World organ is needed to capitalize & implant automated consumer industries in poor countries; rurality & its farming need replacement (not reestablishment); with fast transport & all communications, rurality works best as decentralized work stations, part-time residences and retirement places for urbanites of all income levels.

Adef

24

STASIS :

The World's cities are enlarging
from floods of rural folk,
and becoming physically and mentally exhausting
to their residents,
as well as being ungovernable.

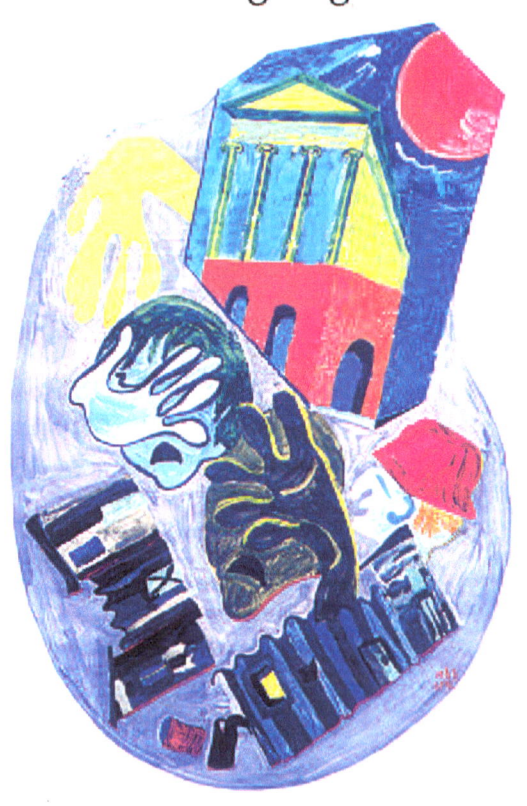

THESIS :

Cities, with half the world's folk,
need self-government and, with their hinterlands,
a direct role in world government;
volunteers, chosen by skill and lot,
should build hundreds of new cities.

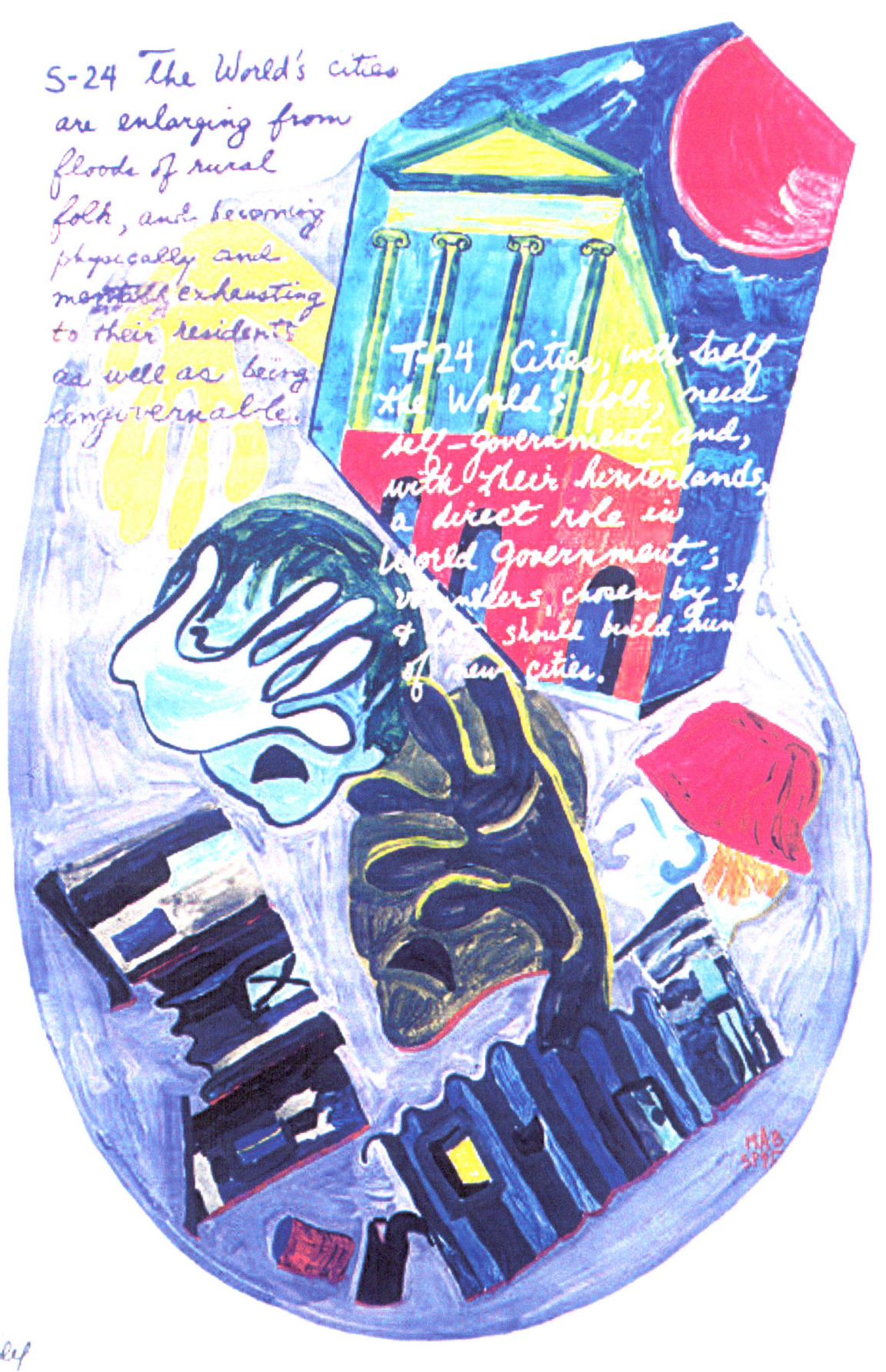

25

<u>STASIS:</u>

Justice everywhere suffers from FIVE severe Improbabilities:
that a true offense is labeled a crime;
a crime is followed by arrest;
and an indictment matches the offense;
and any given trial will be rational;
and the penalty will tend to cure both
the offender and the society.

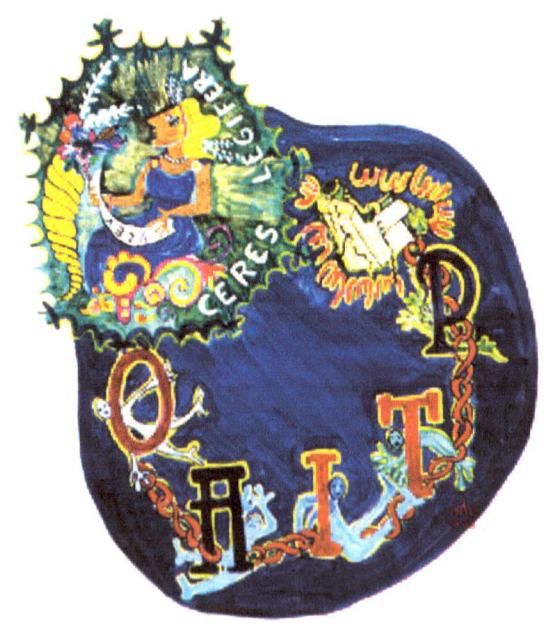

<u>THESIS:</u>

Existing law should be recodified,
according to KALOTIC PRINCIPLES;
the system of litigation should give way to mediatory
and educative methods of coping with deviance;
law-drafting should be an Applied Science
particularizing goals of Legislatures.

S-25 Justice everywhere suffers from FIVE severe improbabilities: that a true offense is labeled a crime; & a crime is followed by an arrest; and an indictment matches the offense; and any given trial will be rational, and the penalty will tend to cure both the offender and the Society

T-25 Existing law should be re-codified according to KALOTIC PRINCIPLES; the system of litigation should give way to mediatory & educative methods of coping with deviance; law-drafting should be an Applied Science, particularizing goals of legislatures

26

STASIS:

Legal and Social disqualifications based upon race,
ethnicity, religion, sex, poorness, non-schooling, and youth,
brand three-fourths of Earth's residents;
every government profits from some prejudices,
and most states excite disqualified groups
to fight among themselves.

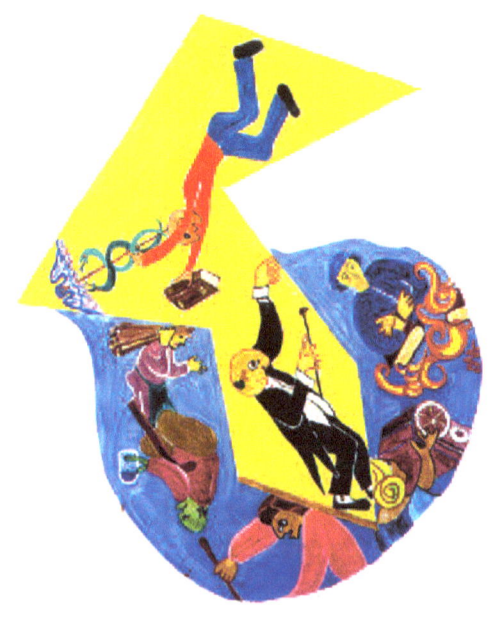

THESIS:

Vicious social discrimination can be reduced
by concurrent changes
in elites, institutions, and personality:
heavy political pressures being brought
to bear on all of these.

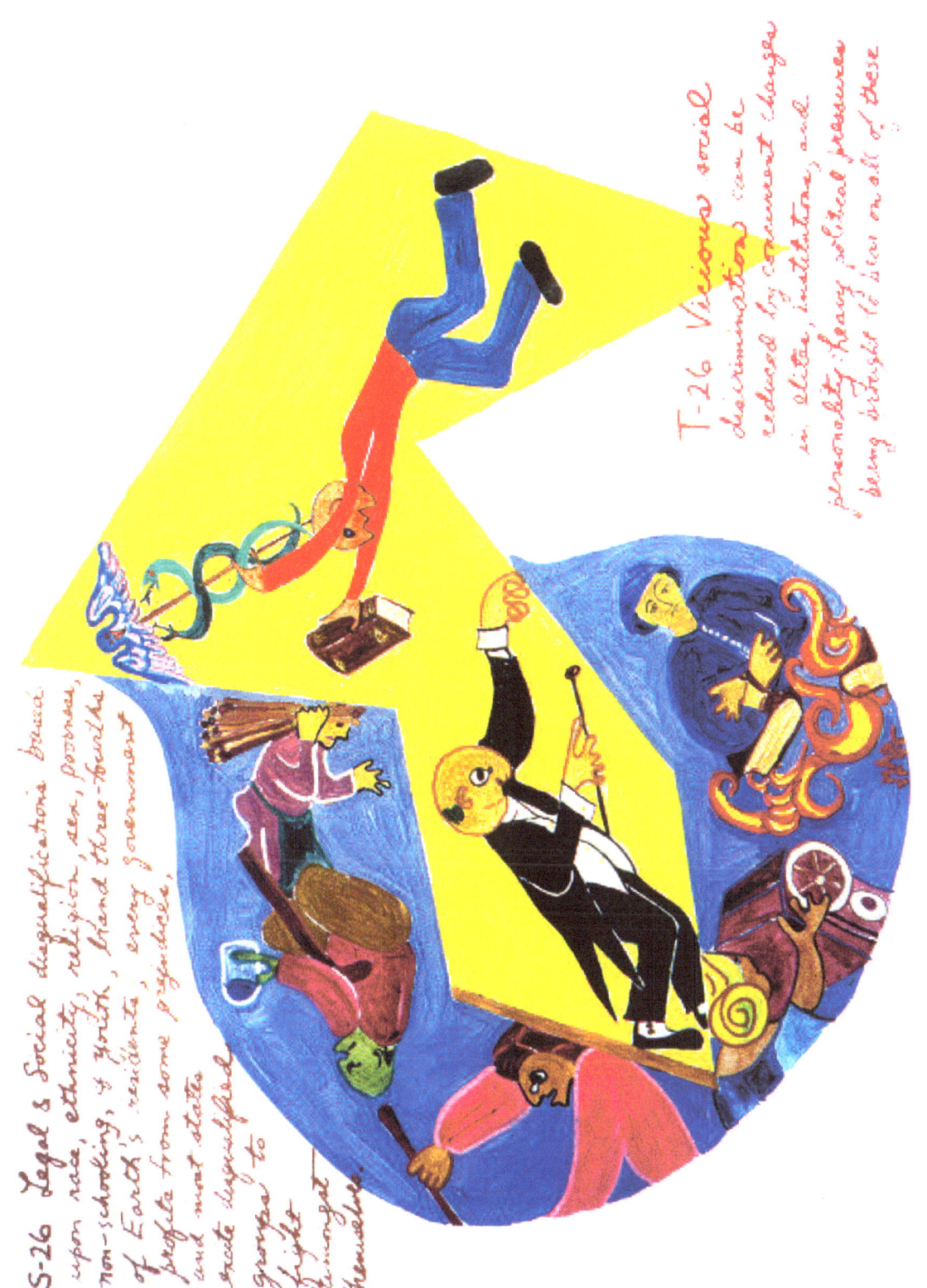

S-26 Legal & social disqualifications based upon race, ethnicity, religion, sex, personal non-smoking, & youth, brand three-fourths of Earth's residents. Every government profits from some pigeonhole, and most state-made disqualified groups to fight amongst themselves.

T-26 Vicious social discrimination can be reduced by government changes in elites, institutions, & personality; heavy political pressures being brought to bear on all of these.

27

STASIS :

Socialism and capitalism
are dead attitudes toward property,
for, whether the state or the rich
own most the assets of all nations,
is indifferently evil.

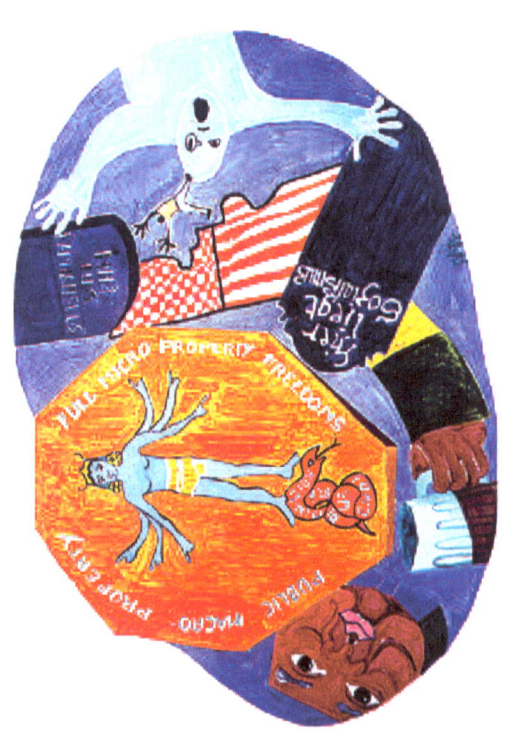

THESIS :

Macro-property should be public, publicly owned,
profitable to the public, and publicly accessible to control;
top ranks of property-controllers are to be open to
chance and merit; the right to hand down estates is restricted
to modest help for dependents;
micro-property, such as small business,
should be employed with full freedoms.

S-27 Macro property should be public, privately owned, profitable, publicly accessible to the public, and top members of property controllers are to be open to change and restricted thought to hand down restricts to nodest sums; micro-property, such as small business, should enjoy full property freedom.

S-27 Socialism & Capitalism will not attain the transfer property, because whether the State or the rich can may if the most of all nature is insufficiently bad.

28

STASIS :

Science may become scientoid and ungovernable;
both the laissez-faire creed of its specialists
and establishments, and the reified nature
said to be its subject and ruler,
are intolerable myths,
spawning malpriorities and dysproduction.

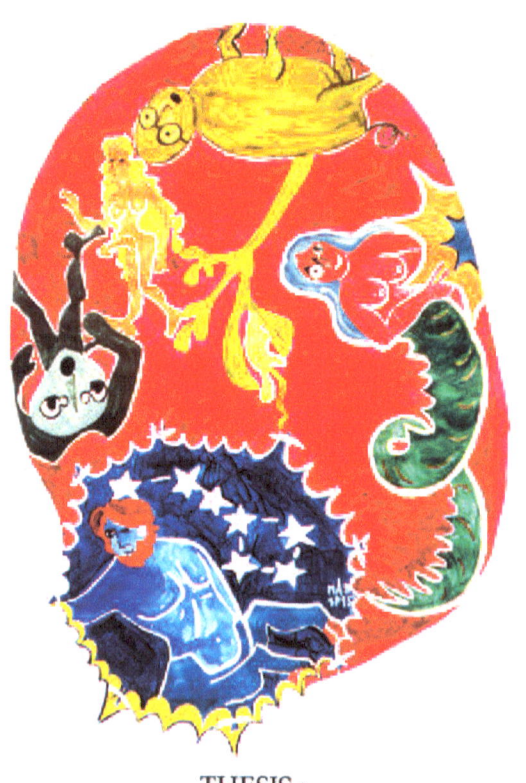

THESIS :

Science, properly construed as hypotheticals
in free association with social problematics,
is the inevitable and only means
of achieving humane goals,
both of PERSONALITY and SOCIETY.

S-28 SCIENCE may become scientoid & ungovernable, creed of its specialists & establishments, (& the reified nature) both the laissez-faire said to be its subject & rulers, are intolerable myths spawning malfeasance & dysproduction.

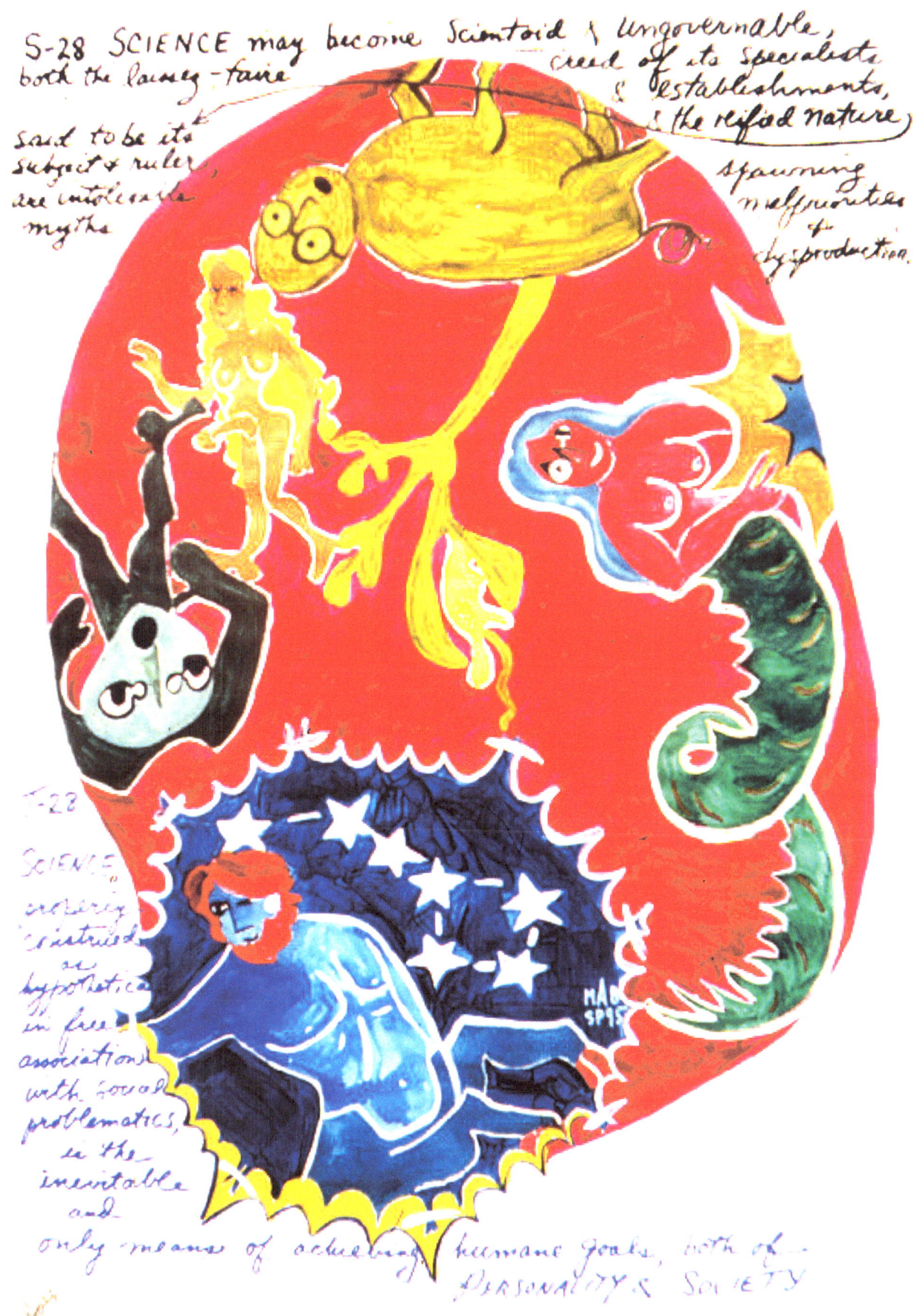

S-28 SCIENCE crosserly constructed as hypothetical in free associations with social problematics, is the inevitable and only means of achieving humane goals, both of PERSONALITY & SOCIETY

29

STASIS :

The crisis of authority, the material madness of plutocracy,
and the failure of taxocracy with respect
to humanism and productivity, attract continually
the intercession of dictators, and ultimately a succession
of personal rulers with ever greater pretensions,
and ever less effectiveness.

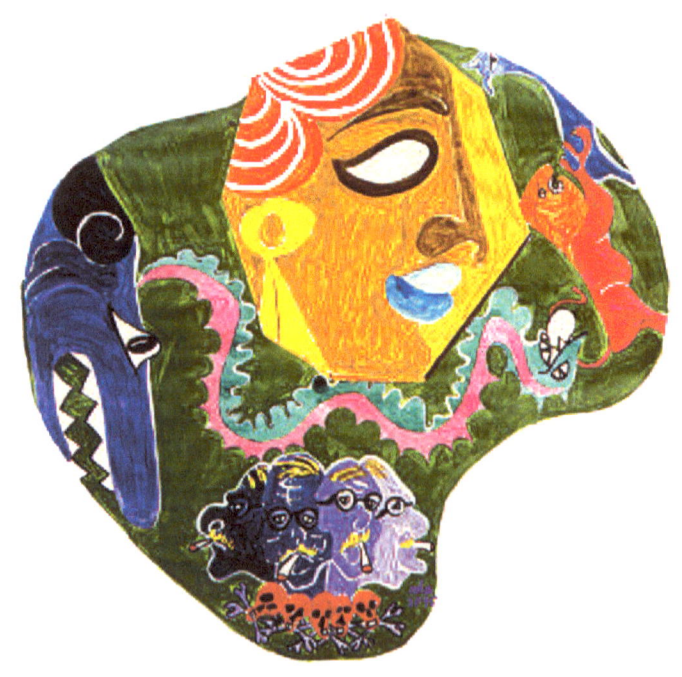

THESIS :

The success of any future government
must be the success of republics.
Old appeals of limited obedience, turnover in office,
free public processes, and extensive consultation
through participation and representation,
must be respected in new complete forms.

S-29. The crisis of authority, the material madness of plutocracy, and the failure of laocracy with respect to humanism and productivity, attract continuously the intercession of dictators, and ultimately a succession of personal rulers with ever greater pretences and ever less effectiveness.

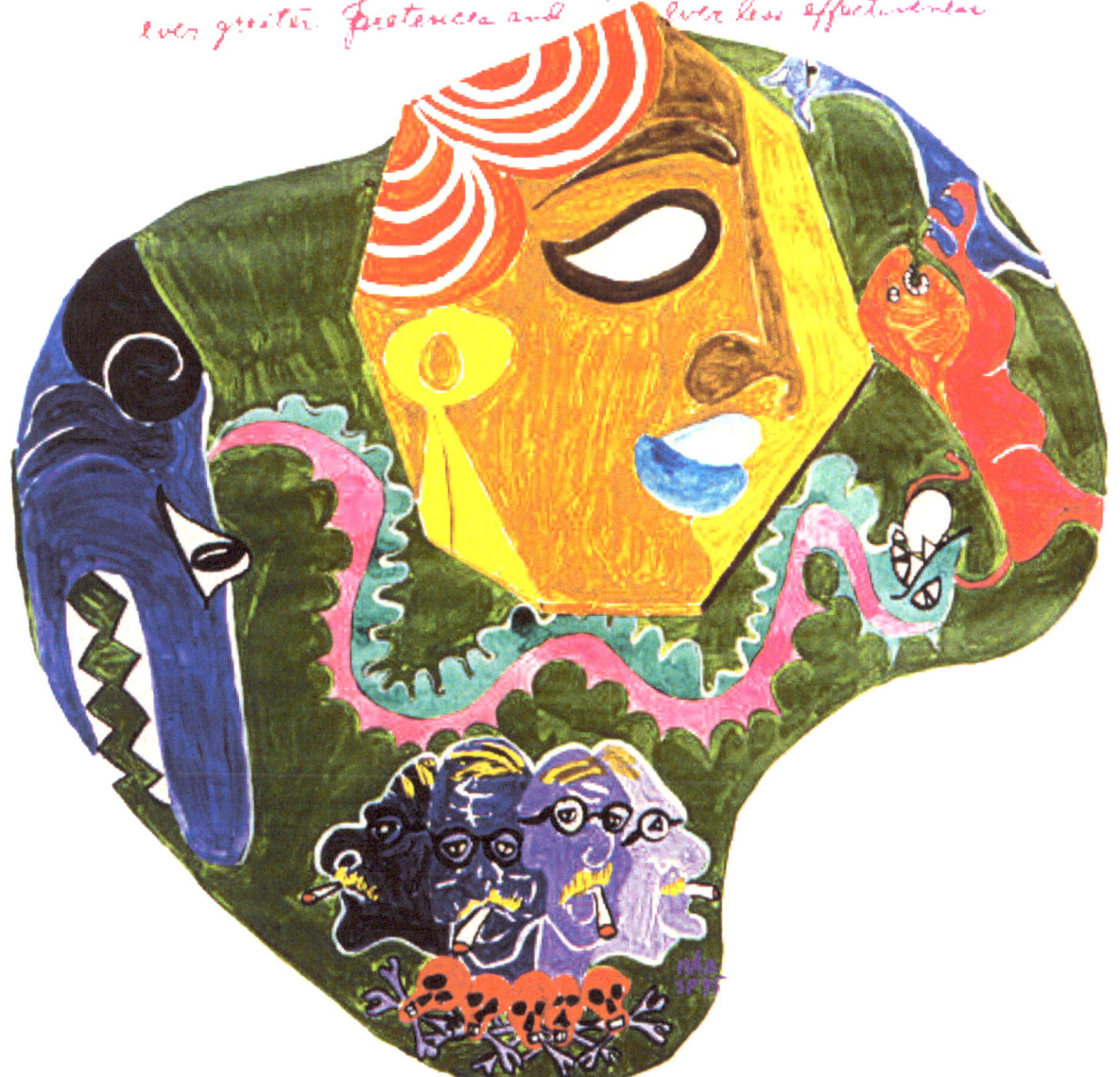

T-29. The success of any future government must be the success of republics. Old appeals of limited obedience, turnover in office, free public processes, and extensive consultation through participation and representation, must be respected in new complete forms.

Adolf

30

STASIS :

The world grows crowded because of
more births, prolonged life-spans,
higher physical mobility, and desperate urban body-jamming;
economic measures so far taken
in order to contain and cultivate growth
are mere desperate palliatives.

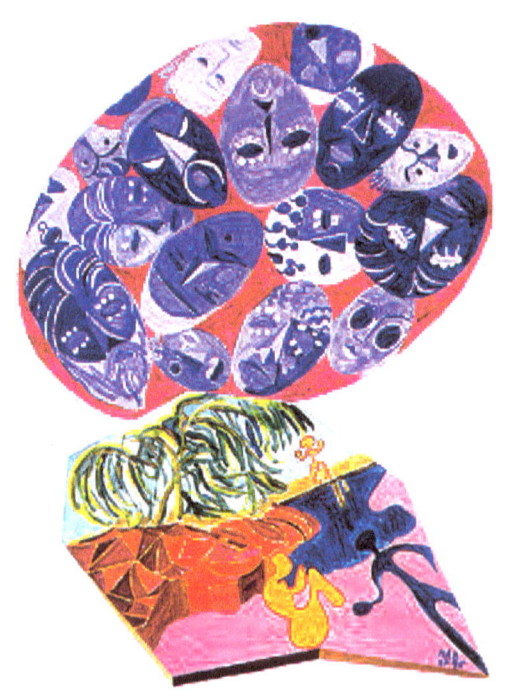

THESIS :

World population increase can be halted by medicines,
ideological pressures, and especially
by licensing births according to a quota
based on personal competency and national statistics,
while conceding a right of motherhood
even to the healthy and irresponsbile. .

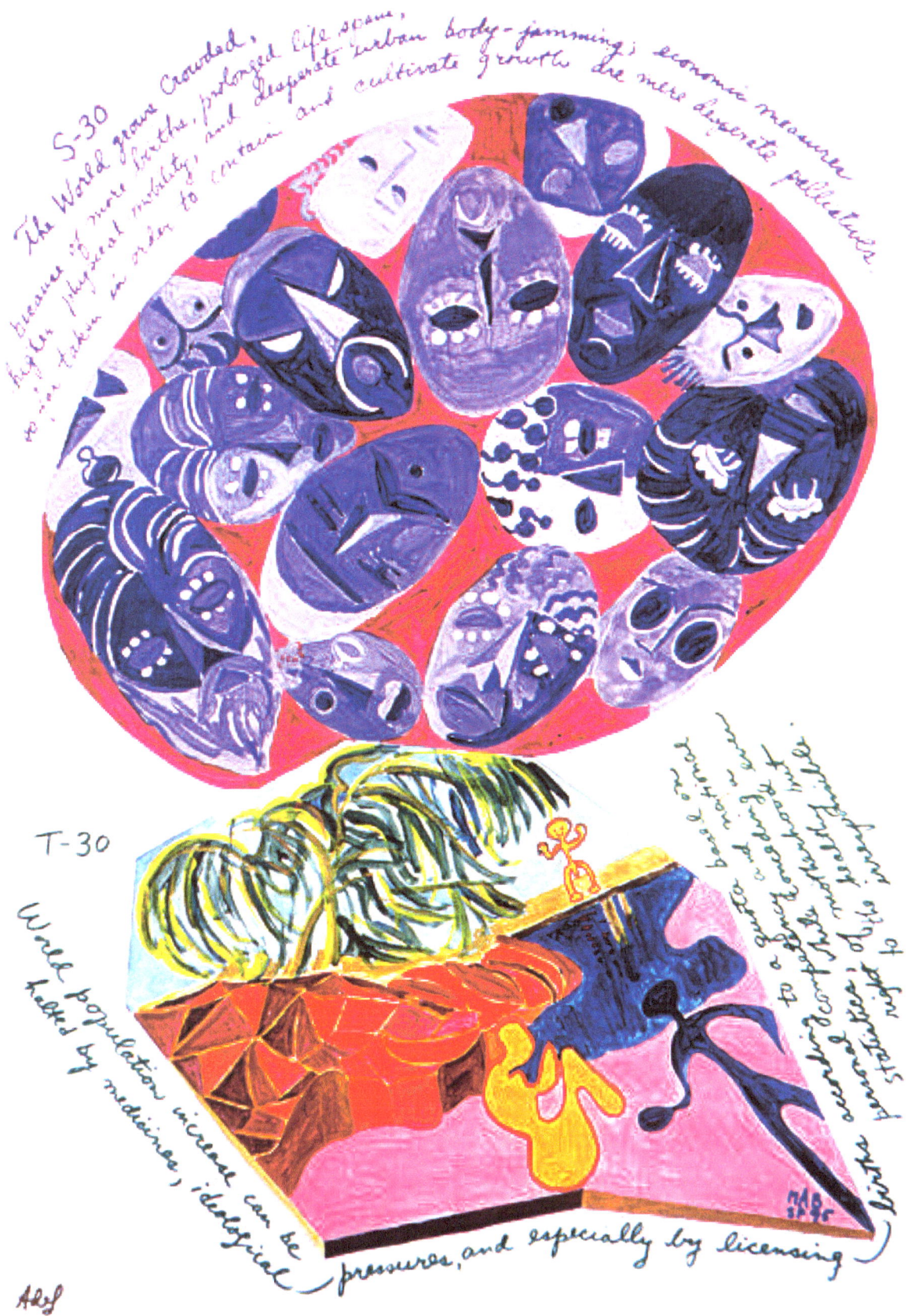

S-30 The World grows crowded, because of more births, prolonged life span, higher physical mobility, and desperate urban body-jamming; economic measures or ion taken in order to contain and cultivate growth are mere desperate palliatives.

T-30 World population increase can be halted by medicines, ideological pressures, and especially by licensing births according to fair statistics of how many people can be accommodated comfortably in inhabited areas, or even to a greater degree in newly developed areas.

STASIS:

No traditional elite can lead
KALOTIC revolution on a worldwide scale.
Clergy, businessmen, ordinary politicians, bureaucrats,
labor leaders, and the military are Incompetent for the task;
only the communist and Fascist parties
learned to combine agitation, organization, force:
but made revolts of immense destruction.

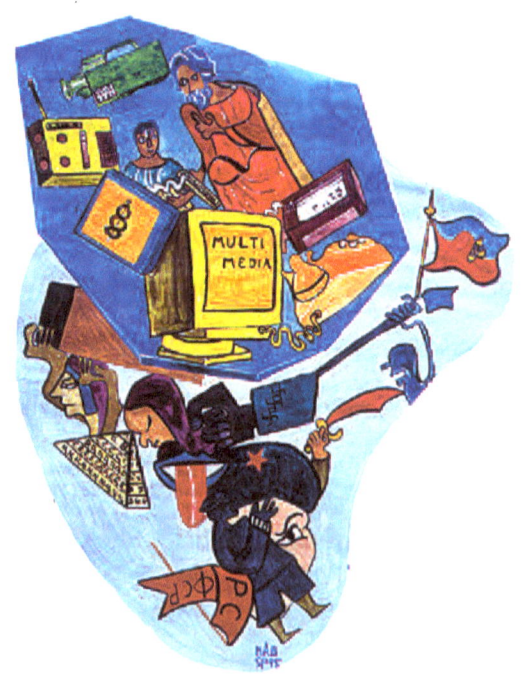

THESIS:

Beneficial revolution requires an ability
to relate the most modern of machines
and communications techniques to people,
plus a human power of tutors;
for the greatest task is to teach,
and the spirit and need of Kalotic revolution
is is TEACHING in Small Groups.

S-31 No traditional elite can lead KALOTIC revolution on a worldwide scale. Clergy, businessmen, ordinary politicians, bureaucrats, labor leaders, and the military, are incompetent for the task; only the Communist & Fascist parties learned to combine agitation, organization, force: but made revolts of immense destruction.

T-31 Beneficial Revolution requires an ability to relate the most modern of machines & communication techniques to people, plus a human power of tutors; for the greatest task is to teach, & the spirit & need of KALOTIC Revolution is TEACHING in Small Groups.

32

STASIS:

Established, yet frightened,
Interests divert Revolutionary Sympathizers
by melioristic promises,
and freeze out advocates of drastic change;
all regimes today are crafty enough
to espouse this type of liberalism.

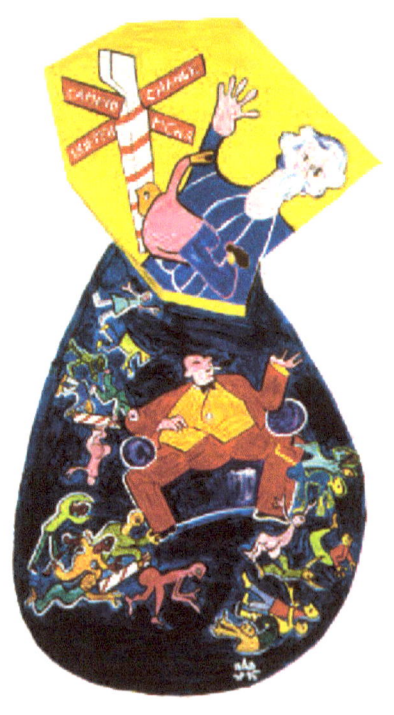

THESIS:

For revolutionary change, Votes, Petitions, Discussions,
Associating, and Lobbying must be supplemented
by Stressed Democracy devised to reach
the removed and protected targets of the Establishment:
picketing, boycotts, passive resistance, samizdats,
free Parallel Operations, Demonstrations, Confrontations,
Tithing, and Virtual Institutions and Governments.

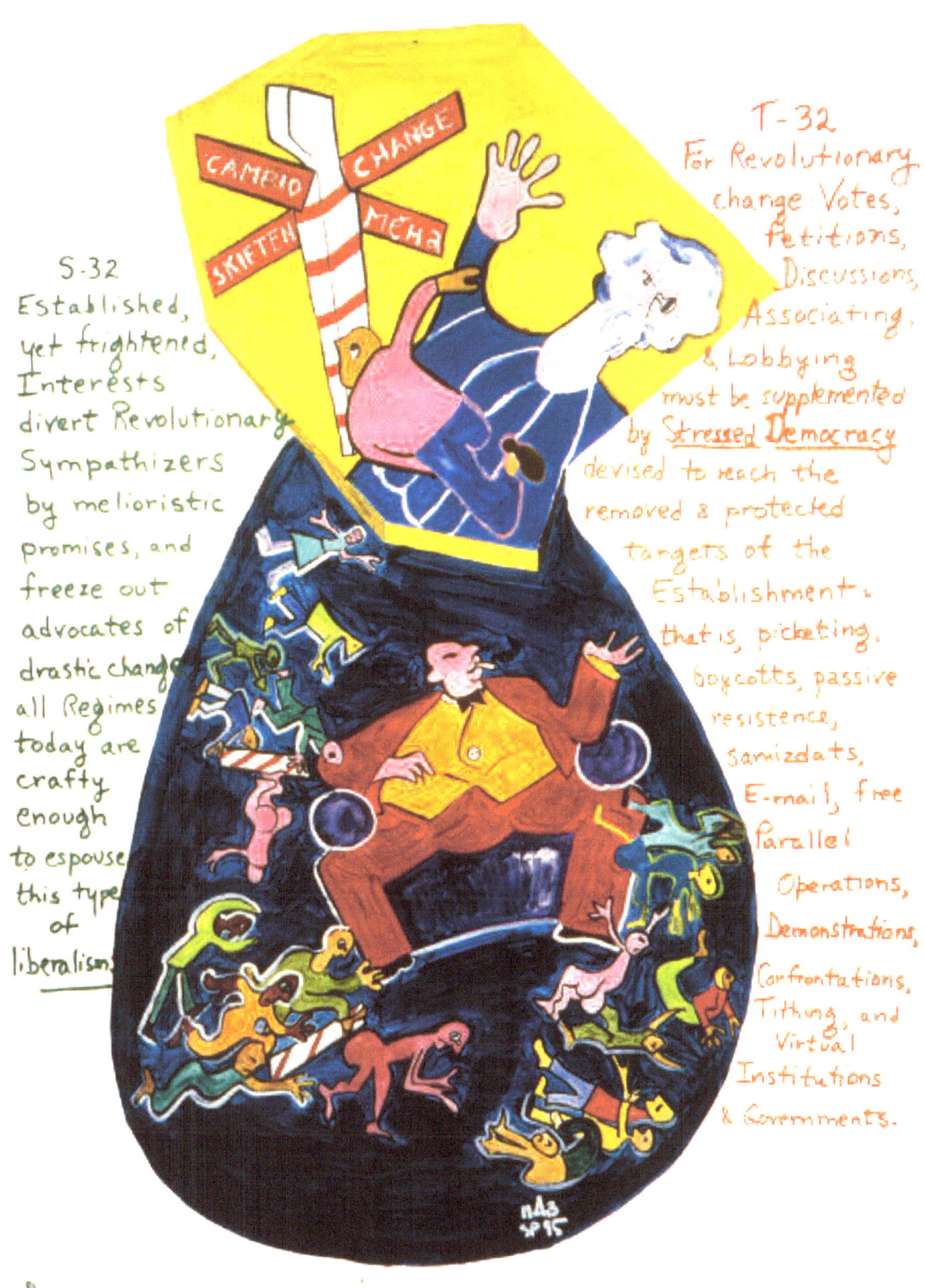

S-32
Established, yet frightened, Interests divert Revolutionary Sympathizers by melioristic promises, and freeze out advocates of drastic change; all Regimes today are crafty enough to espouse this type of liberalism.

T-32
For Revolutionary change Votes, Petitions, Discussions, Associating, & Lobbying must be supplemented by <u>Stressed Democracy</u> devised to reach the removed & protected targets of the Establishment, that is, picketing, boycotts, passive resistance, samizdats, E-mail, free Parallel Operations, Demonstrations, Confrontations, Tithing, and Virtual Institutions & Governments.

33

STASIS :

World revolution, as large-scale radical change,
accomplished quickly, is presently occurring,
unguided by human minds,
and its projected overall effects
will be negative and precipitate
immense constraints and suffering.

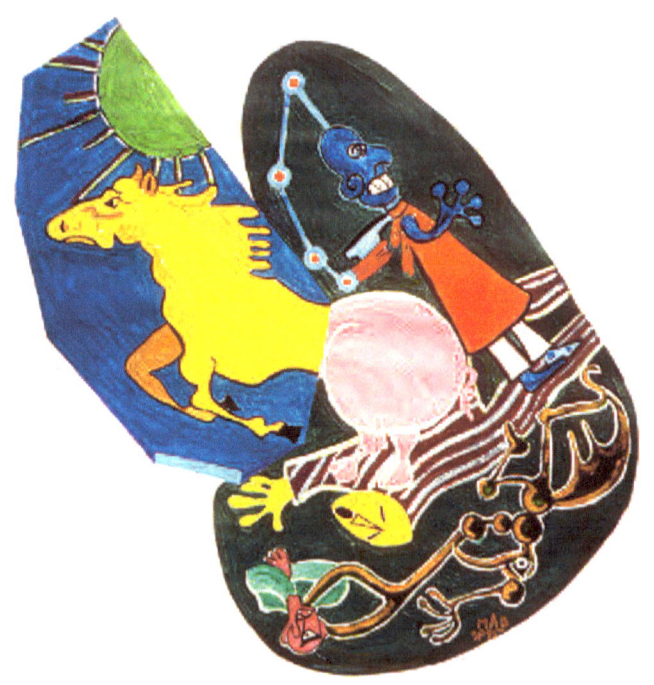

THESIS :

The cost of planned revolution,
in assembling wills, investing resources,
and overcoming obstacles is far less
than costs of resignation to the predictable effects
of the uncontrolled forces of today's world.

S-33 World Quantavolution, as large-scale radical change, accomplished quickly, is presently occurring, unguided by human minds, and its projected overall effects will be negative and will precipitate immense constraints and suffering.

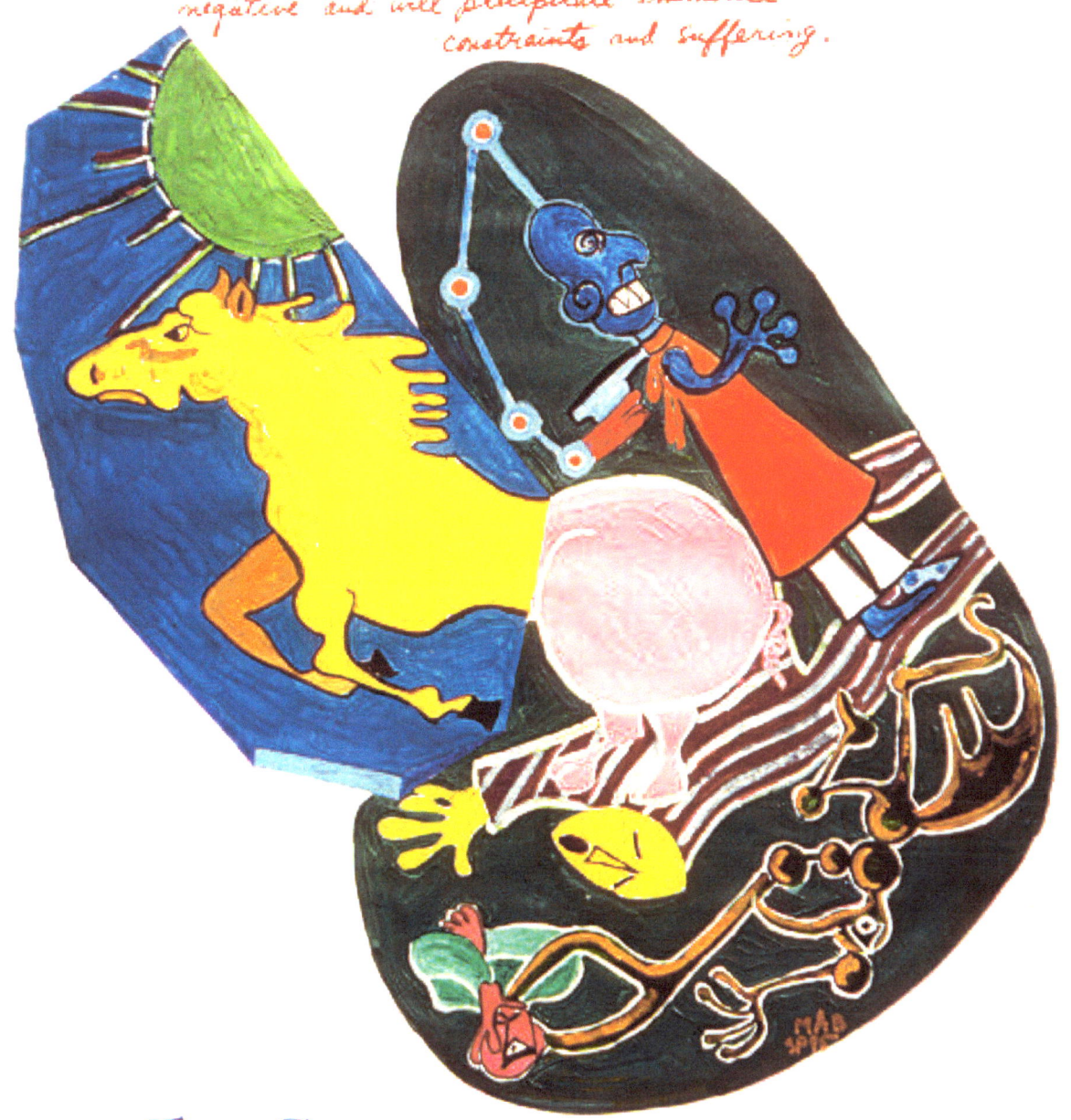

T-33 The cost of planned Quantavolution, in assembling wills, investing resources, & overcoming obstacles is far less than the cost of resignation to the predictable effects of the uncontrolled forces of today's world.

34

STASIS :

The destructiveness of revolutions
comes from the ingrained hostilities
of the wretched and impotent,
the resistance of vested interests,
absence of phased goals,
and factional struggles among the rebels.

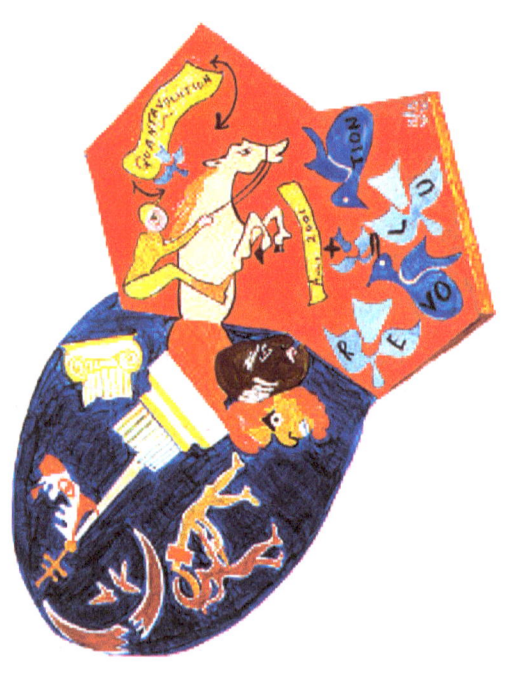

THESIS :

Compatibility of means and ends,
though it may cost the Quantarevolution dear,
guarantees that the revolution won
is the revolution to be enjoyed.

S-34 The destructiveness of revolution comes from the ingrained hostilities of the matched & unipotent, the resistance of vested interests, absence of phased goals, & factional struggles among the rebels.

T-34 Compatibility of means and ends, though it may cost the Quantavolution dear, guarantees that the revolution won in the revolution to be enjoyed

35

STASIS:

Even if converted, the present disordered elites
of capitalist, communist, and fascist regimes,
out of opportunism and defensiveness,
can be aggressive against change

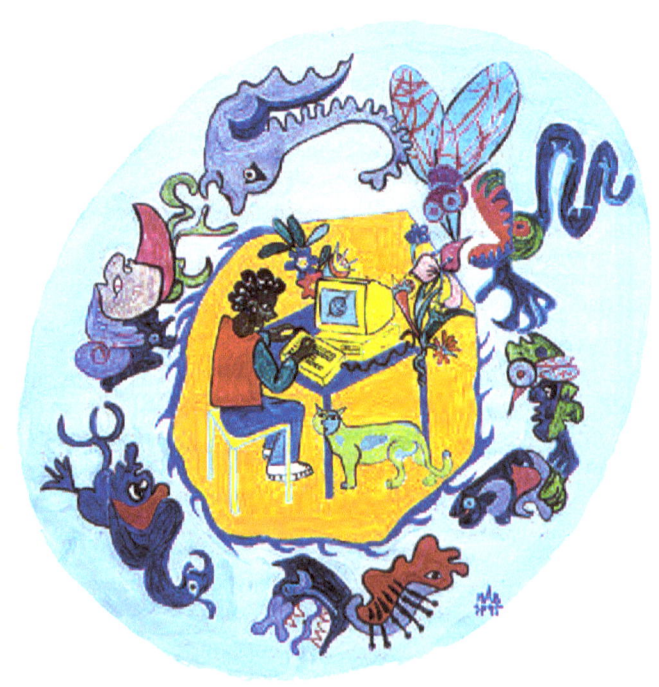

THESIS:

A cool revolution is best:
violence rejected in principle;
all peaceful means of rapid, large-scale beneficial change,
that the opposition will accept are pursued;
but the right remains to define violence,
to resist violence in self-defense,
and to counter-revolutionary conspiracy.

S35 Even if converted, the present disordered elites of capitalist, communist & fascist regimes, out of opportunism & defensiveness, can be aggressive against change.

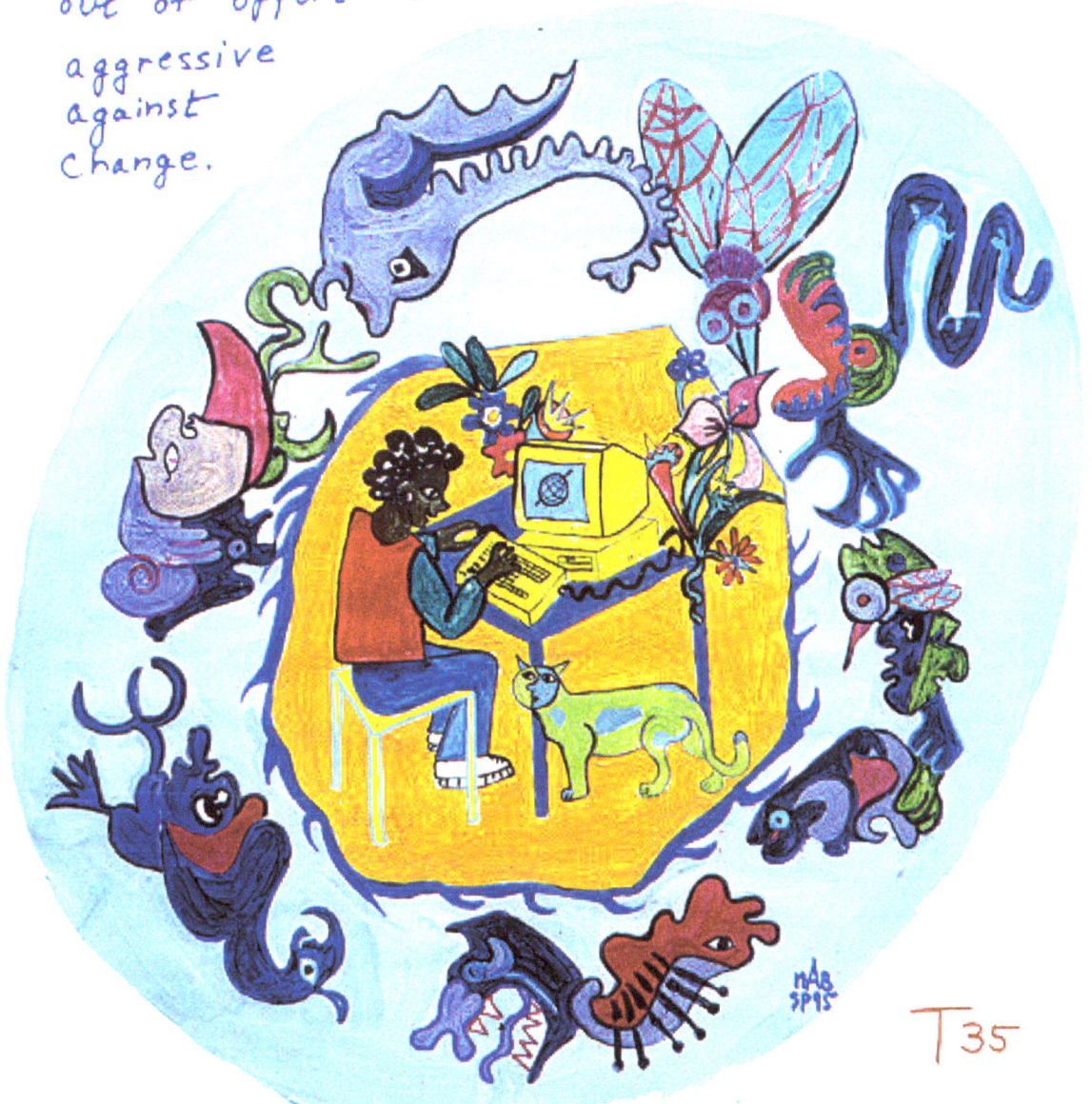

T35

A cool Revolution is best: violence rejected in principle; all peaceful means of rapid, large-scale change, that the opposition will accept are pursued; but the right remains to define violence, to resist violence in self-defense & to combat counter-revolutionary conspiracy.

36

STASIS :

National governments play crazily
upon malicious history and sovereignty
in a cruel game of "dog eat dog,",
refereed, restrained, and goaded
by a few great powers,
who themselves are participants.

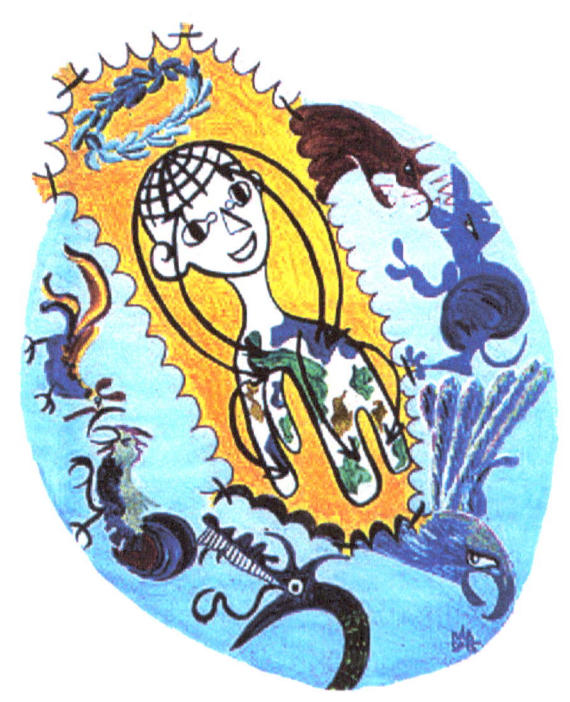

THESIS :

Powers and functions of nations,
internal and external,
are reduced by a World Movement
dominating single states and working from them,
by complementary, functional, World Representation,
and relaxing restraints on Ethnic Sub-nations.

S36 National governments play crazily upon malicious history & sovereignty in a cruel game of 'dog-eat-dog' refereed, restrained, and goaded by a few great Powers, who themselves are participants.

T36
Powers and functions of Nations, internal and external, are reduced by a World Movement dominating single states and working from them, by complementary, functional, World Representation, & by relaxing restraints on Ethnic Sub-Nations.

37

STASIS:

The momentum of armaments competition
frustrates any great drive to solve World problems;
it promises sudden death to large parts of Humanity,
including, ironically, those who are potentially equipped
to solve the problems; a First strike is Evil,
a Return Strike is misanthropic suicide.

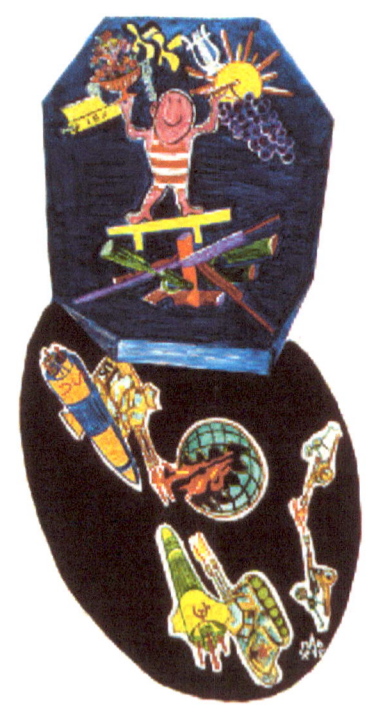

THESIS:

UNILATERAL INITIATIVE in DISARMAMENT
can avoid destruction,
free energy for solving social problems,
transfer large resources to WORLD AID agencies,
and win sympathy for
WORLD RECONSTRUCTION.

S 37

The momentum of armaments competition frustrates any great drive to solve World problems; it promises sudden death to large parts of Humanity, including, ironically those who are most able to solve the problems; a First Strike is Evil; a Return Strike is misanthropic Suicide.

T 37
UNILATERAL INITIATIVE in DISARMAMENT can avoid destruction, free energy for solving social problems, transfer large resources to WORLD AID agencies, and with sympathy for WORLD RECONSTUCTION.

38

<u>STASIS :</u>

A laissez-faire, or imperial, or balance-of-power,
or unstructured world order,
cannot cope with the present World revolution;
revolution in one country,
no matter how large or small,
must be incomplete and vulnerable.

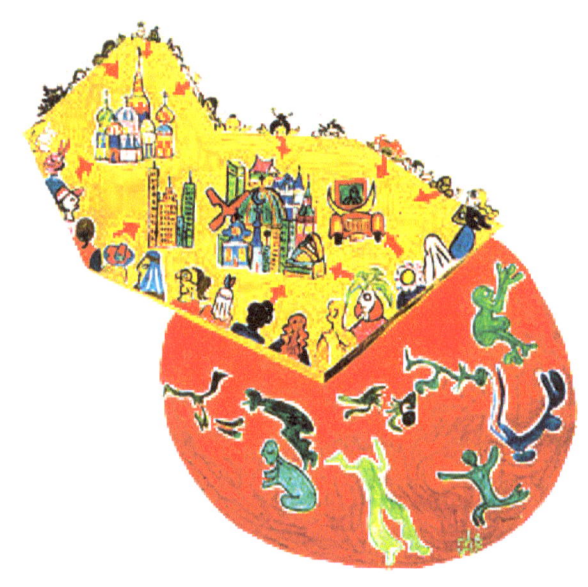

<u>THESIS :</u>

A new COSMARCHY is formed of a Congress
of Representatives of Regions, Nations,
Functional Associations, Urban Communities,
and all Individual Persons.
The COSMARCHY begins as one Region,
which by fission evolves the elements of new Regions,
until the World is assembled by regions
corresponding to Cultures and Political Systems.

S38 A laissez-faire, or imperial, or balance-of-power, or unstructured world order, cannot cope with the present world revolution; a revolution in one country, no matter how large or small, must be incomplete and vulnerable.

T38 A new COSMARCHY is formed of a Congress of representatives of Regions, Nations, Functional Associations, Urban Communities, and All Persons; The COSMARCHY begins as One REGION, which by fission evolves the elements of new Regions, until the World is assembled by regions corresponding to cultures and Political Systems.

39

STASIS :

The human sciences, which began anciently as utopias,
and have completed their second stage
during World collapse and transformation,
expose in hundreds of studies
how stiff is resistance to change,
and how slow is beneficial progress.

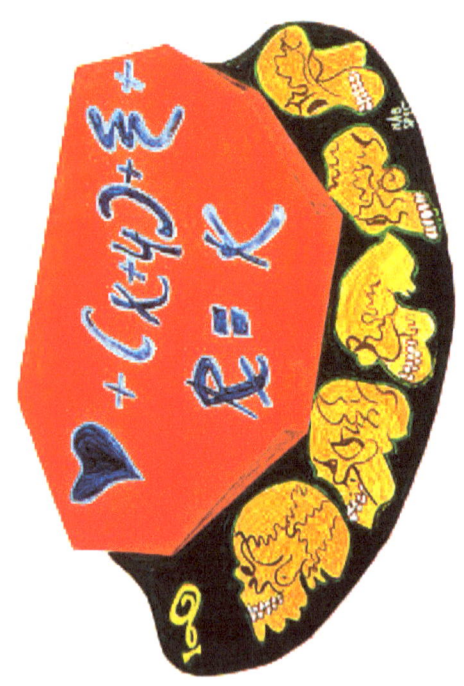

THESIS :

Kalokinesis is the science
of speeding up beneficial change:
zeal + power, if they are scientifically guided,
make both large changes
and small changes swift and easy.

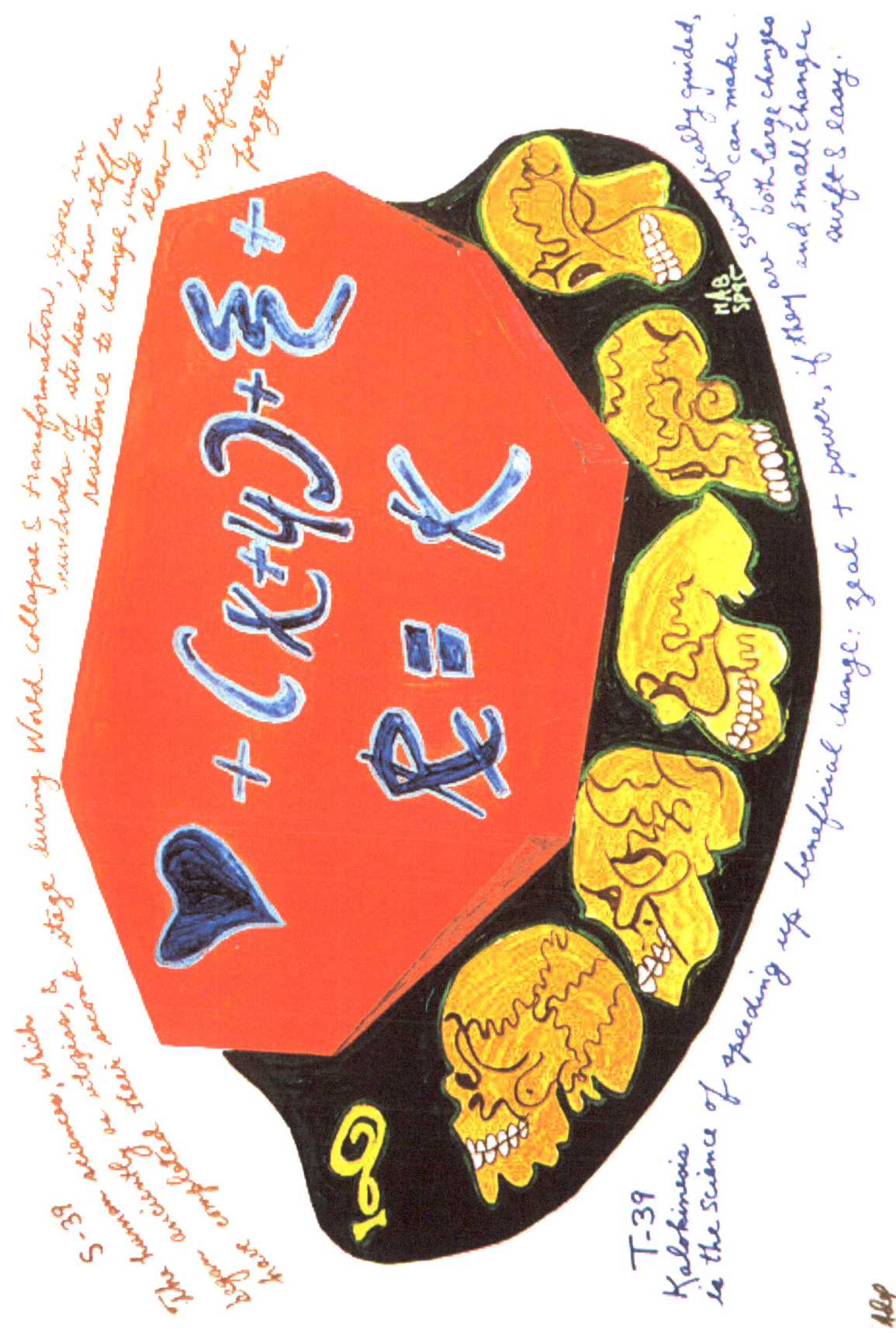

S-39 sciences, which are anciently an utopian 6 stage during World collapse & transformation. Signs are hundreds of status: how stiff is resistance to change, with how slow to beneficial progress. The outrighted their power before completed.

T-39 Kalahineia is the science of speeding up beneficial change: zeal + power, if they are scientifically guided, can make both large changes and small changes swift & easy.

40

STASIS:

Established religions give men souls to keep,
but are ritualistic, dogmatic and escapist;
violent revolutions exhilarate upon succeeding,
but they lend souls to men,
and then take them back.

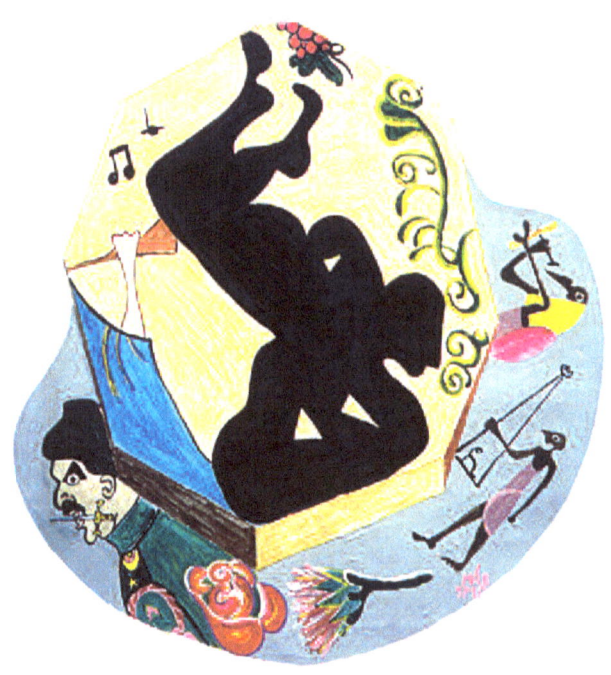

THESIS:

The condition of one's existence
is to be ever-open, operational, idealist,
integrative of body and soul,
and therefore a mirror
of the social fusion of material and spiritual;
this is the philosophy of future humanity.

S-40 Established religions give men souls to keep, but are ritualistic, dogmatic, and escapist; violent revolutions exhilarate upon succeeding, but they lend souls to men, and then take them back.

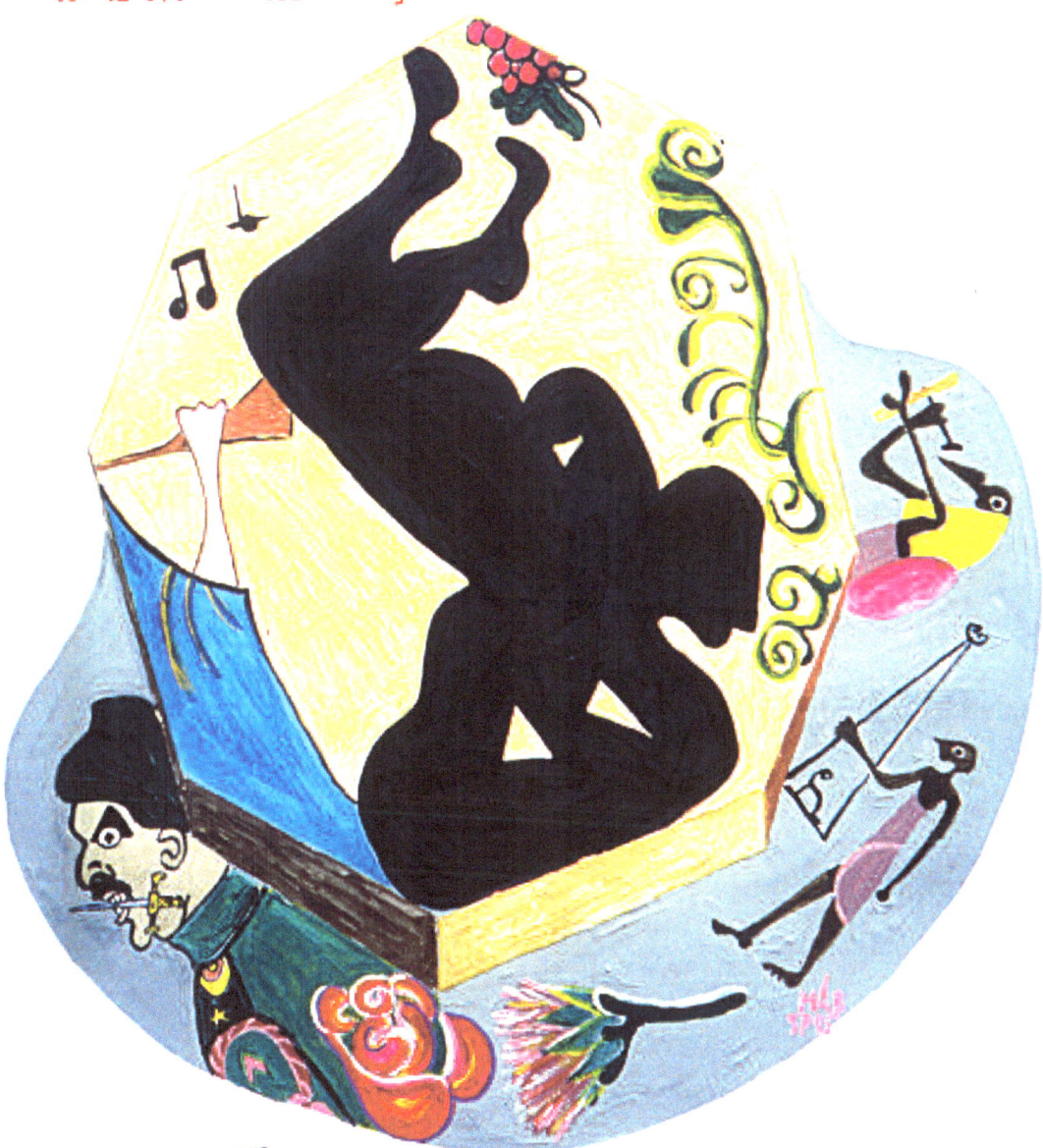

T-40 The condition of one's existence is to be ever-open, operational, idealist, integrative of body & soul, & therefore a mirror of the social fusion of material & spiritual: such is the philosophy of future humanity.

The Artist: Licia Filingeri

Licia Filingeri Gaietto is an artist active in Genoa (Italy). She specializes in young colleagues participating in clinical groups. She pursued her artistic activity from 1972, for three decades, expressing herself in painting and sculpture on social themes. Since 1976, she collaborates with her husband, sculptor and archaeologist Pietro Gaietto, taking care of the editing and graphics part of his work.

Email: filingeri@fastwebnet.it

The Author: Alfred de Grazia

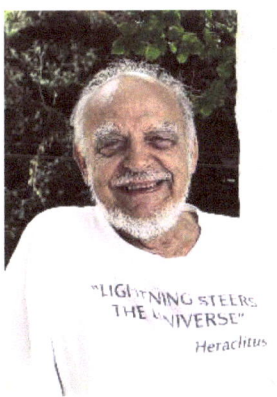

Alfred de Grazia was born in Chicago in 1919. He studied at University of Chicago (MA, PhD). As a soldier, he participated in seven campaigns in WWII. As a political scientist, he taught at University of Minnesota, Brown University, Stanford University, New York University and authored some thirty books. He turned to catastrophism and ancient history, creating the field of QUANTAVOLUTION, in which he wrote a dozen books. He also wrote two books of poetry, plays, and several autobiographical works.

Website: http://www.grazian-archive.com

www.ingramcontent.com/pod-product-compliance
Lightning Source LLC
Chambersburg PA
CBHW051022180526
45172CB00002B/440